A History Of Writing and Printing

FROM CAVE PAINTINGS TO PIXEL

ALINARI

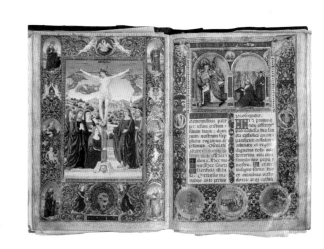

Editorial Manager
Giovanna Naldi

Graphic Design
Lorenzo Mennonna

Layout and graphics
Media Studio, FI

Iconographic Research
Alessandra Biagianti

Print
Grafiche Arcari

Cover Photo
Alinari
Mugs with paint covered
brushes used for decorating
ceramics,
Montelupo Fiorentino, 1992
Alinari Archives, Florence

Table Of Contents

6 History of Writing and Printing

22 Printable Media

44 Gutenberg and the Impact of Printing

62 The Briefest of Histories of Print

82 Inks

HISTORY OF WRITING AND PRINTING

The history of writing and printing is closely related to the history of human communication. Three revolutions mark the history of human communication:
- The invention of writing to capture spoken words.
- The invention of book printing to publish information to a broad audience.
- The invention of personal printing to personalize content, to personalize the process of printing itself and to allow for individual content and creativity.

The common denominator of preserving written words and images is to make them last, make them eternal, steal them from the pace of time. Spoken words are gone with the wind, what is written remains for generations.

As mankind developed, both in size and intellectually, the need for information and its exchange developed. This increased request for information lead to ever new inventions of enhanced communication. Cave paintings are some of the first records of communication – although there exist many theories to whom this communication was targeted, whether it was meant as a record of oneself, or rather to put animals under a spell and be able to hunt them down, is not clear.

Thousands of years later, the skill of writing allowed for ever more sophisticated documentation and communication. The art of printing, finally, enabled people to communicate to large audiences. And, printing text was en-

hanced to include printing images. You could argue that today the circle is closed - printing photos in a way goes back to the power of cave paintings: you capture the moment, your picture says more than a thousand words.

Sharing information, archiving and growing knowledge was so important to mankind that a lot of efforts were made to develop several media and processes, including carving stone, clay, wood, making papyrus into sheets, scraping leather to parchment, etc. How simple has it become for us today to push the "print" button and pick up a document, a chart or a photo only seconds later?

Writing is one form of transmitting coded information from sender to receiver. The coded data, for example speech describing an object, a process, a feeling or whatever, is classified and interpreted by the receiver, and by this process the receiver is enabled to interact with the sender.

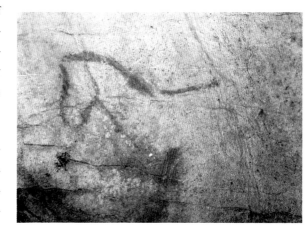

Unidentified Photographer
Horse figure (c. 40000-12000 BC),
Cueva de la Pileta, Benaojan
Bridgeman/Alinari Archives, Florence

This is called a semiotic process. Semiotics is the science of signs or codes.

Codes are really another medium to capture and frame emotions and transmit them. Since the coding, especially when it came to written codes, was quite cumbersome, only the most important information was coded – for example the Bible or the Chinese I Ging, which is presumably the oldest book. Being the content of written information or later owning books and being able to read them was a luxury reserved to few people only.

This has changed with Gutenberg, who made books a mass medium. In the centuries to come, many people could afford books and enjoy the knowledge coming along with them. Knowledge would lead to further progress, but could also lead to turmoil. The peasant war, for example, is seen as directly linked to the German translation of the Luther Bible and book printing. Ironically, one of HP's EMEA headquarters for imaging and printing is based in Böblingen, Germany, where the peasant armies lost one of their biggest battles in 1525. The Böblingen Peasant War Museum still tells that story today.

For centuries printing was a trade requiring specialists, special machines and processes and special knowledge. A whole industry emerged.

But with making the printing process available to the masses in the late 1980s HP, often referred to as "the printer company", finally put the production of written information into the users' hands.

Again, a circle is closed. Initially, individuals communicated with individuals. Gutenberg's invention allowed a few to communicate to the masses. And in the age of the internet and personal printing not only is everybody empowered to communicate with everybody, but also are we able to personalize our messages. Just imagine what our ancestors would have left us if they already had that modern technology.

Thanks to the Alinari Archive we have insights into old family photos and photographed documents linked to the topic of writing and printing.

Ralf Leinemann, January 2006

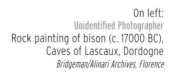

On right:
Unidentified Photographer
Rock painting of ponies
(c. 17000 BC),
Caves of Lascaux, Dordogne
Bridgeman/Alinari Archives, Florence

On left:
Unidentified Photographer
Rock painting of bison (c. 17000 BC),
Caves of Lascaux, Dordogne
Bridgeman/Alinari Archives, Florence

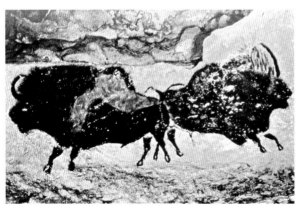

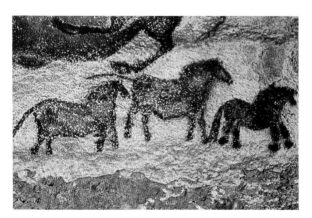

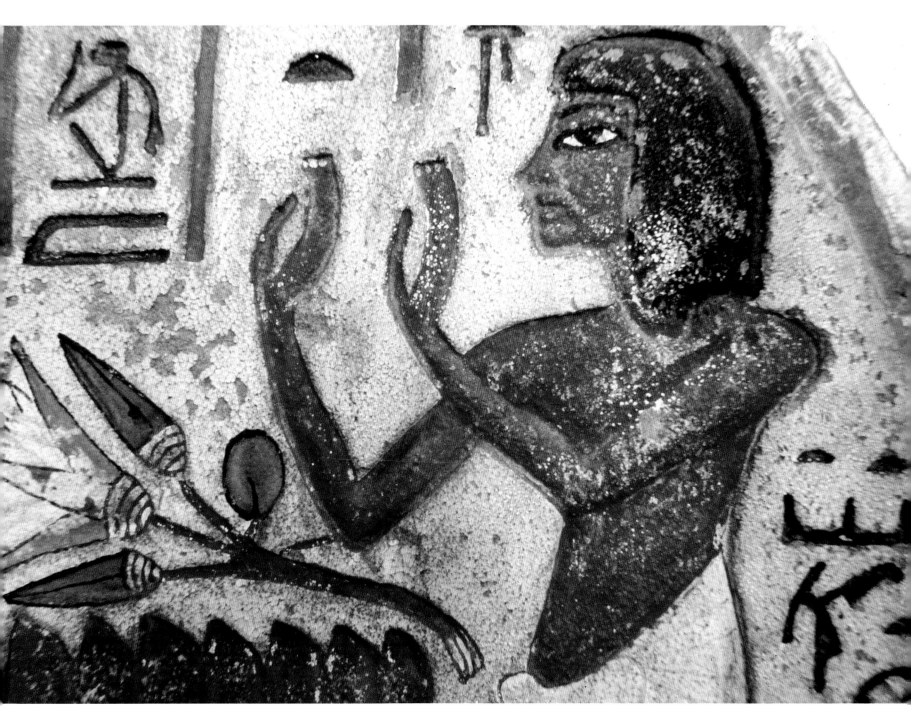

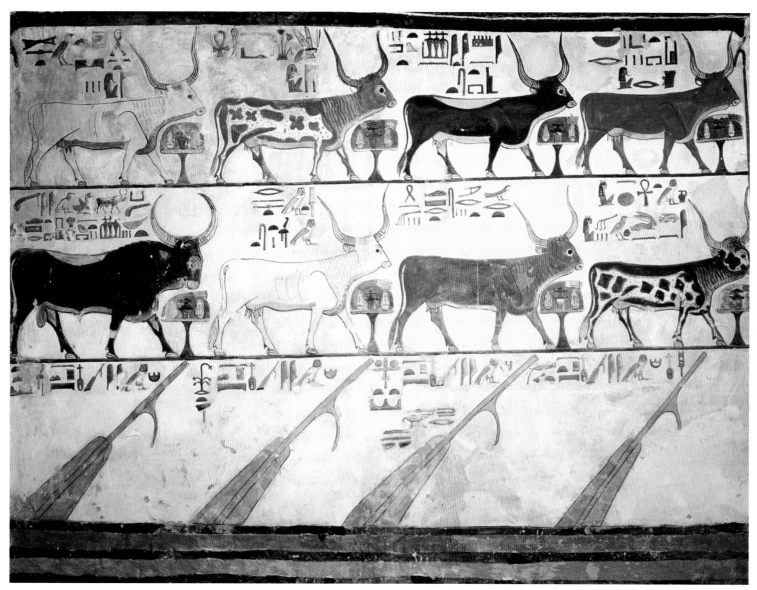

On left:
Detail of a family funerary stele, conserved at the Museo Egizio in Turin. A male figure is depicted, probably the defunt, in the act of oration and making an offering to the divinity, 1990 ca.
Alinari Archives, Florence

On right:
The seven celestial cows and the sacred bull and the four rudders of heaven, from the Tomb of Nefertari, New Kingdom, wall painting Egyptian, Valley of the Queens, Thebes
Bridgeman/Alinari Archives, Florence

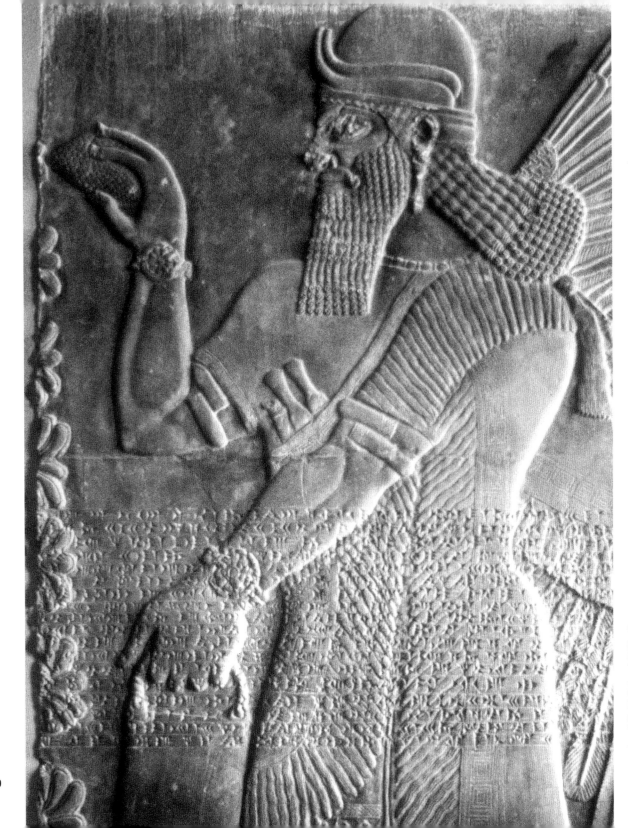

On right:
Alinari
Relief of Pharaoh Nectanebo I, showing the sovereign making offerings to statues of animal gods and a ritual hieroglyphic inscription running along the top, located at the Museo Civico Archeologico, Bologna
Alinari Archives, Florence

On left:
Alinari
Detail of an Assyrian relief from the Palace of Assurnasirpal II in Nimrud, depicting a winged genius holding a pinecone and a situla, Louvre Museum, Paris, 1990 ca.
Alinari Archives, Florence

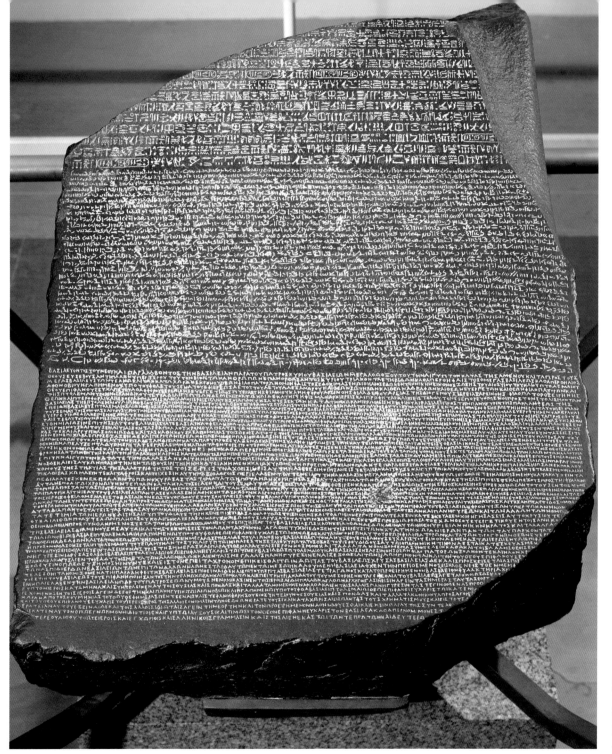

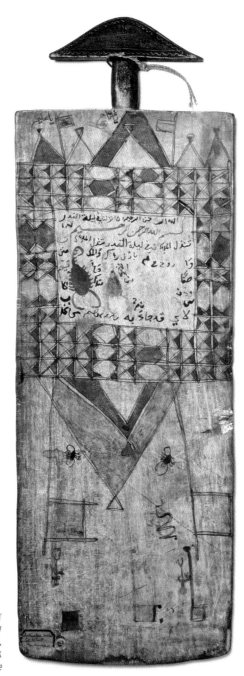

Unidentified Photographer
Haggai reproving Zerubbabel and Jeshua, from the Farfa Bible, vellum by Spanish School, Private Collection
Bridgeman/Alinari Archives, Florence

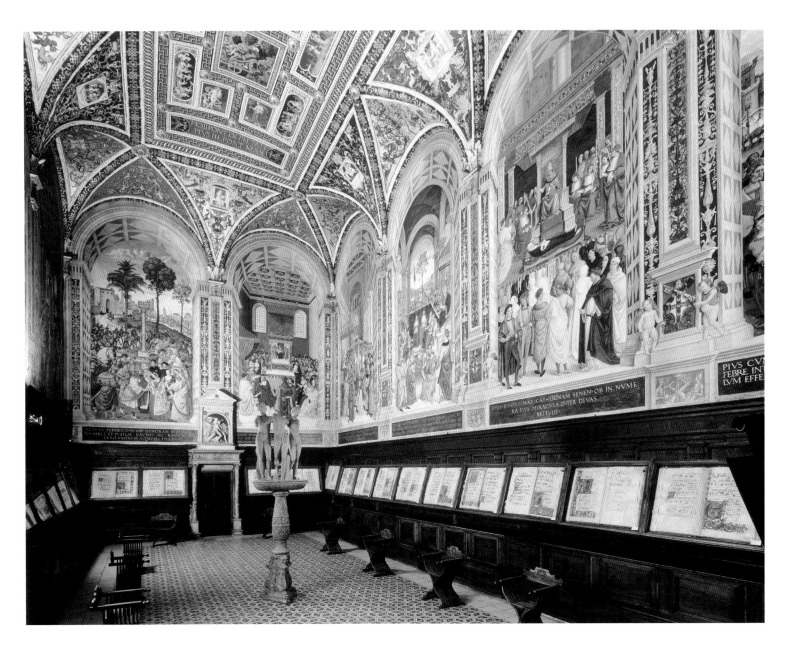

Ghigo Roli for Alinari
Interior of the Piccolomini
Library, in the Cathedral of
Siena, 2002
Alinari Archives, Florence

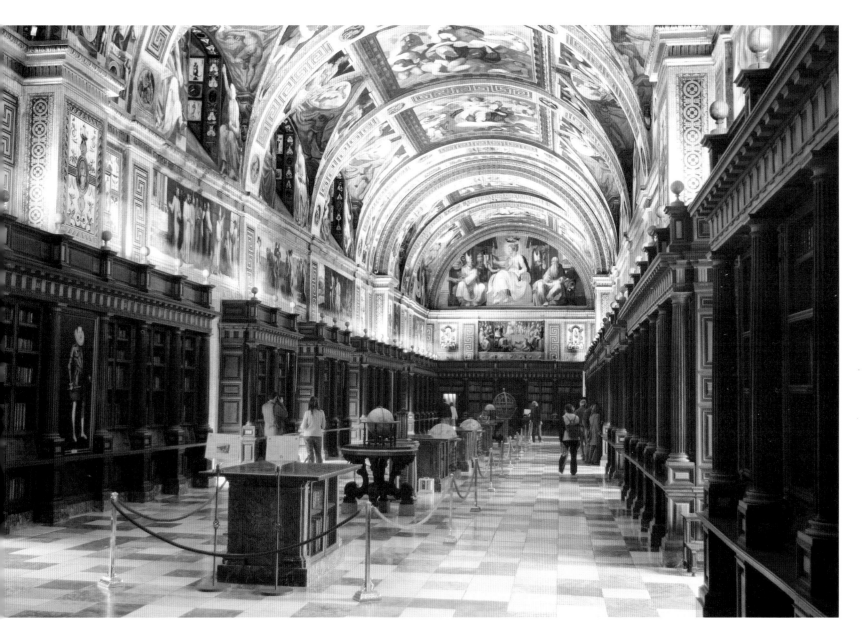

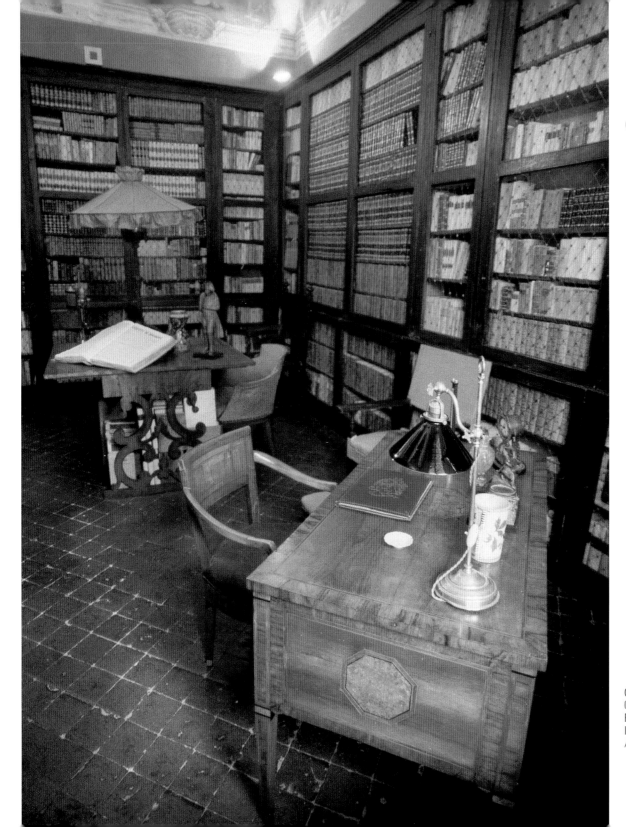

On right:
Unidentified Photographer
Caricature of the French writer,
Emile Zola; drawing by André
Gill, published in the newspaper,
"L'Eclipse" (April 16, 1876),
1910 ca.
Roger-Viollet/Alinari, Florence

On left:
Gianfranco Moroldo
Palazzo Tozzoni studio,
Imola, 1983
Alinari Archive Management, Florence

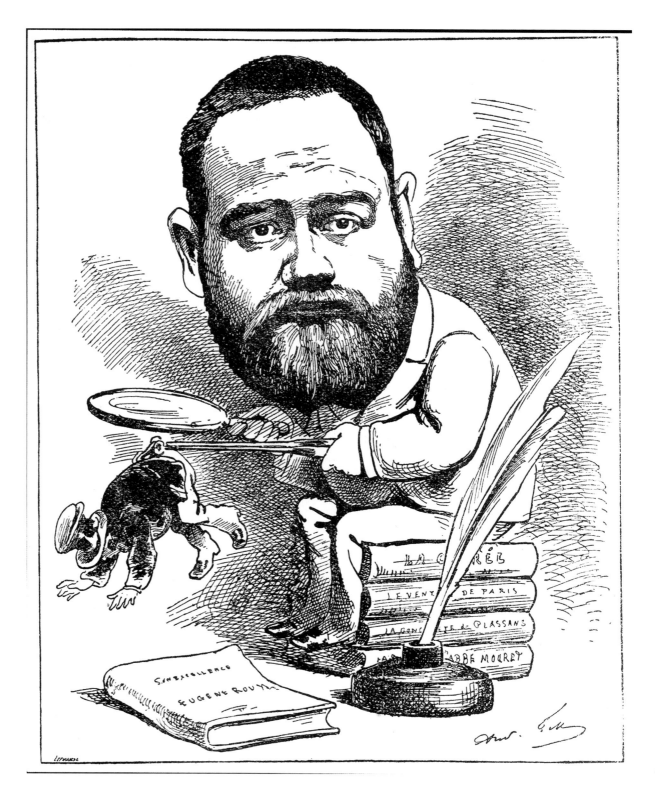

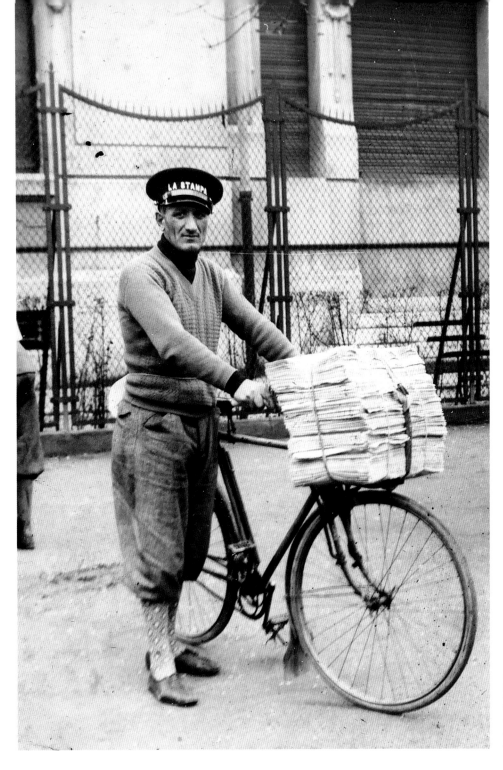

Pietro Bellini
Newspaper seller photographed
at a cycling race, 1940 ca.
*Fratelli Alinari Museum of the History of
Photography - Falzone del Barbarò Collection,
Florence*

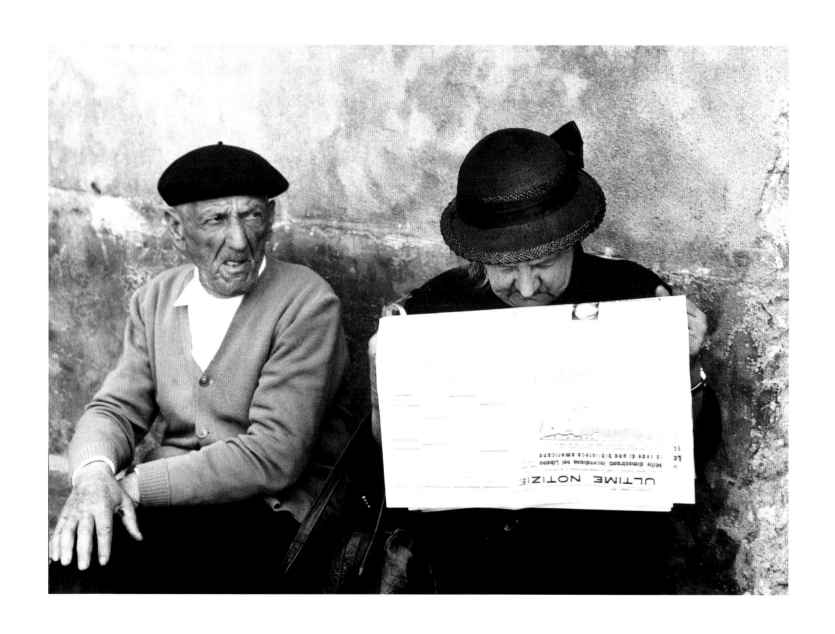

Nils P. Miller, Ph.D.
Printable Media

Ancient forms of writing, and art, were applied to a variety of materials - e.g. stone, wood, dried animal skins - with whatever colored materials were available. Thus, stone, wood can be considered early examples of printable media.

However, as print media, stone and wood (and vellum and parchment from animal skin) are not ideal. An ideal printable medium is not only flexible and thin - so it can be easily stored and transported, but is well-suited to being manufactured in large quantities.

In this earliest "paper" made from Cyperous Papyrus circa 3000 B.C., thin strips were cut from the stem of marsh grass, and layered together to form a mat after being softened in water. The mat could then be pressed into a thin sheet and dried in the sun.

What might be called the first true paper came from China over 2,000 years ago. Around 105 A.D., T'sai Lun experimented with and greatly advanced the process by which fibers of plants were completely separated - i.e. "refined" - and were then mixed to form a water slurry. By moving a screen up through this slurry, a thin layer of very wet fibers was formed on the the screen, and this layer could then be dried. The key to the formation step of paper is encouraging the properly-refined individual fibers to intertwine and bond so that the resulting paper has the desired smoothness, opacity, and strength.

As with many technological advancements, this papermaking process stayed in China for some time. However in the 3rd century A.D. it came to Vietnam and Tibet, and later was introduced in Korea and Japan. In aesthetic and technological terms, Japan has contributed much to the art of papermaking, and today continues to play an artisan role in tandem with the art of calligraphy.

From these areas of Asia, papermaking spread through Nepal and India. Papermaking in the Western world was made possible via the Islamic civi-

George Tatge for Alinari
'Open parchment book',
painting of German School,
Uffizi Gallery, Florence, 1996
Seat Archive/Alinari Archives, Florence

lizations, who reportedly obtained knowledge of the art of papermaking when they captured several papermakers traveling in a Chinese caravan. When North African Moors invaded Spain they took paper-making technology with them, and from Spain and Portugal it spread into Europe in the 12th century.

There are many types of printable media today. Most are some variation on this basic idea of paper made from individual plant - derived fibers. Some use paper as the core of the substrate only, and have lam-inates or coatings applied. Others, such as transpar-ent plastic films, have no fiber content at all. Each category has a different blend of appearance, flexi-bility, and durability, and can require very different manufacturing techniques.

HP printable media include plain papers, photo papers, coated papers, transparent/translucent films, fabric transfer media, vinyl, canvas, adhesive-backed papers, and fine art papers. With the contin-ued expansion of digital printing technologies (inkjet, laser, dry EP, liquid EP), HP considers how each category applies to our various digital printing technologies.

To get a sense of the design complexity, and the vari-ety of design challenges, the following examples are worth a closer look.

The first example is HP Advanced Photo Paper for inkjet photo printing. The center of this paper is formed from highly refined paper fibers. This refin-ing process, in combination with special inorganic additives, helps determine the opacity and whiteness of the paper - crucial properties for photographic printing. Above and below are resin (plastic) layers, since this is a 'true' photobase. These layers create a water-resistant substrate, and also affect glossiness. Next are the imaging layers, which are designed to

On left:
Luigino Visconti for Alinari
Detail of the 'Book of the Dead of Tsekohns' with scenes of agricultural activies, Egyptian Museum, Turin, 1995
Alinari Archives/Bridgeman, Florence

On right:
Unidentified Photographer
Story of Noah: construction of the ark (detail). Narthex mosaic of the St-Mark Basilica of Venice, XIIIth century
Roger-Viollet/Alinari, Florence

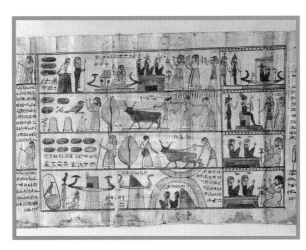

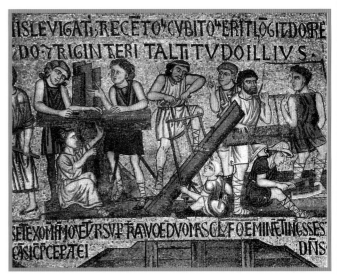

23

receive the ink and colorant. These layers are constructed from specially-modified silica particles; the challenge is how to create particles that are very small (~ 100 nm) and relatively uniform in size and shape. Otherwise, the coating will be hazy, and would not absorb HP inks correctly. Finally, there is the P (as in "protection") layer, which among other things improves scratch resistance.

The second example is HP laserjet brochure media. In general, brochure papers have a top coat (made of clay or other inorganic particles) that gives the

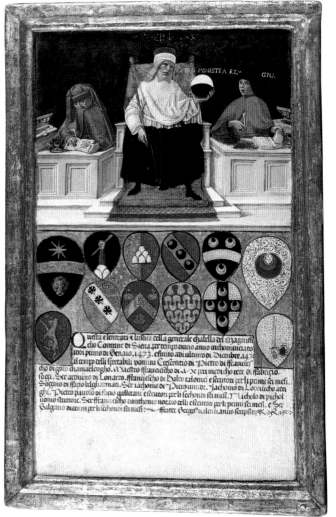

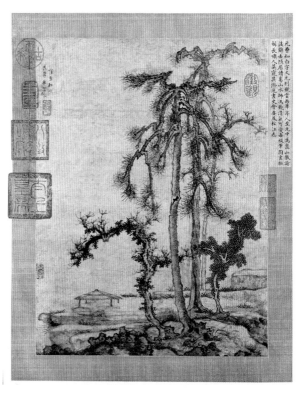

On left:
George Tatge for Alinari
The Good Government in the Office of the Gabelle, painting by Benvenuto di Giovanni, State Archives, Siena, 1995
Alinari Archives/Bridgeman, Florence

desired gloss properties for a vivid, high-quality appearance. But these types of coatings tend to trap moisture within the 'core' paper layer as residual moisture in the paper is heated up during the laser printing fusing process. Result: blistered, uneven appearance. So the challenge - and innovation - required obtaining the necessary gloss and smooth-

On right:
Unidentified Photographer
Pavilion Under the Trees, pen and ink on paper by Cao Zhibo, Musée Guimet, Paris
Bridgeman/Alinari Archives, Florence

ness properties while still maintaining enough open-ness within the coating to allow moisture to escape. Additional innovation was required in the base-layer: this coating needed to have the right electrical conductivity interaction with the charged toner particles that are adhered during the laser printing process.

The third example is HP ColorLok Multi-Purpose Paper. Plain paper technology has come a long way since T'sai Lun's development work 2,000 years ago. The type of fibers, the size of the fibers, wax-like additives that affect the wicking properties of the paper fibers, fillers that affect the paper structure and appearance - all these tools have been refined over the centuries and are reflected in that everyday piece of paper we take for granted. With HP's ColorLok technology, a new approach has been taken. Traditional plain papers tend either to quickly absorb inks (think of a paper towel as an extreme case) in a way that detracts from the richness of the output; or, they contain more wax-like additives that keep the inks near the surface (for rich, vibrant output) but as a result are not immediately dry to the touch. HP ColorLok technology is an additive within the paper that locks the ink colorants at the surface, which allowing the colorless portion of the ink to be quickly absorbed by the relatively "unwaxed" paper fibers.

So three very different types of papers have been discussed, each with their own complexity and technology. However, as with all HP printable media, they share some commonalities. The starting point is an aesthetic and functional one - what is the desired look-and-feel for the printed output? This helps dictate the type of materials required in the substrate material - paper, plastic-encapsulated paper, transparent plastic, woven materials, etc. - and how thick they must be. The next step is understanding how that material will interact with the targeted digital printing technology. Often this step is what triggers the design of multi-layer coatings with the correct physical and chemical properties. The final step requires how to put this all together in a feasible form - known as design-for-manufacture - so that large quantities can be produced at a reasonable cost.

Underlying it all is that basic need, unchanged over the *millennia*, to find ways to communicate information and create art in a form that easily stored and transported.

Unidentified Photographer
Topham Picturepoint, 'Jingo-ji Temple Sutra', Japan, Heian period, mid 12th century. The handscroll records in gold Chinese characters between ruled silver lines the text of the Hachi dai-bosatsu mandara kyà´, The British Museum, London
TopFoto / Alinari Archives, Florence

blans et fleurs de camomille autat
de hug come de laitre soient to
rissées et par especal la fontieze
et boille tont ensemble en eane
dephire Jusques leane remeigne
a lamoitie et puis en retourne la
finnee et aussi lane ses pies en
telle eane et il y vauldra molt
cest exprment merueilleur
pour oster sanete ou espine on
autre chose sithe en la char on
on corps soit prise la rarme de
fontieze et la rarine de fenoil
cestassmon le score de la rarme
et soient ensemble meslees et
v adiouste du unel souffisau
ment et puis boillent en la
parelle de fer Jusques atat quil
sort come en forme demplastre
et soit mis sus il fait merueille

fasier et pourte les fieses et croist en
boraiges et en lieux nets v umbrages
elle vault principalmet contre la
douleur de la rate ¶ Le sus delerbe
come aborce auec unel y profite
monlt ¶ A teulx gui ont apame
leur alaine et gui sont come en
souspirant le sus de teste herbe doue
aborce auec poinze blac et il se
ttarit ¶ Les fruits aussi cestass
les fieses gui les mangeue elles
sont aide aux colericques et tofor
tent lestomac et apaise la soif

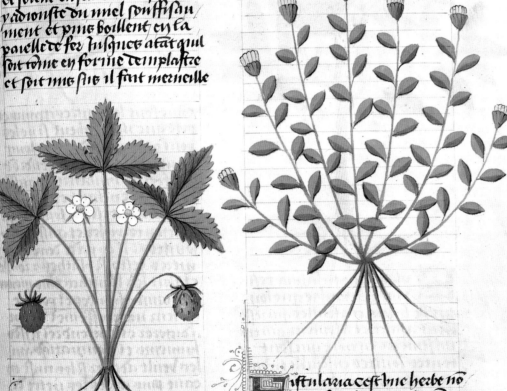

Kaytaria siue fragula
cest une herbe q est appellee

Fistulaia cest une herbe no
mee fistulare et est nomee
taglassona. Cest herbe ressemble
a marozame mais elle est plus
veste et se astmete sur le sanne
come qu'te seuille elle a petite ra

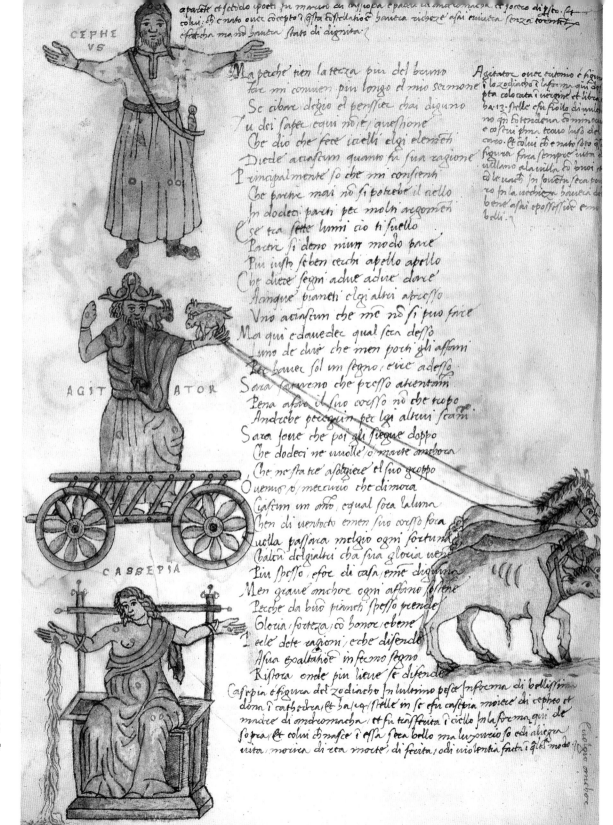

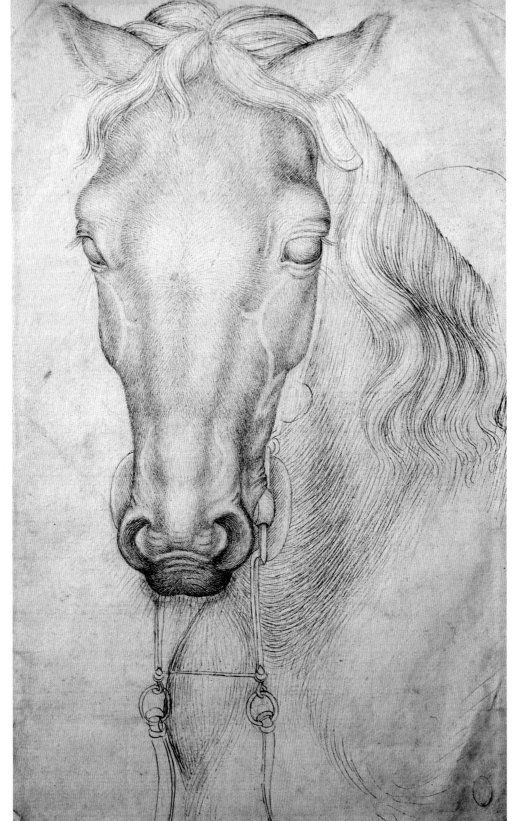

Unidentified Photographer
Head of a horse, pen and ink on
paper by Antonio Pisanello,
Louvre Museum, Paris
Bridgeman/Alinari Archives, Florence

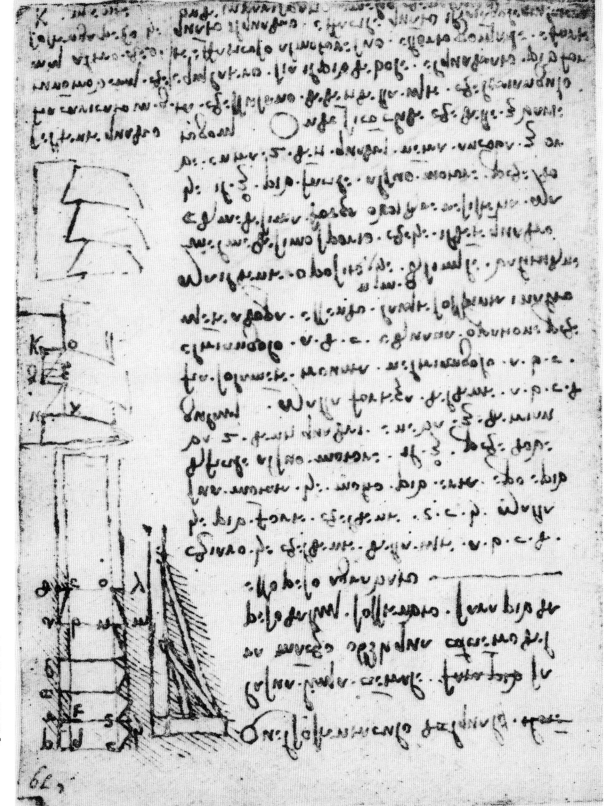

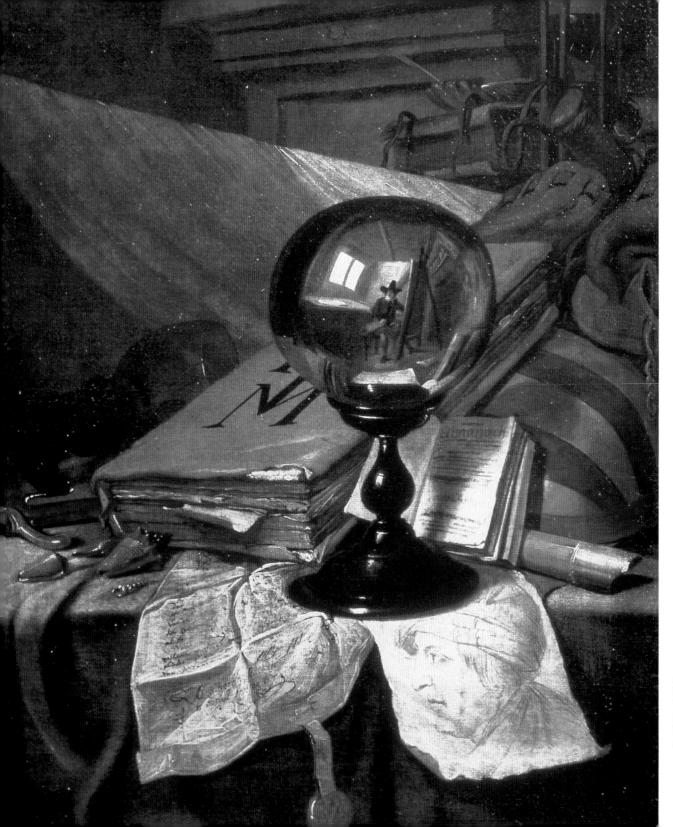

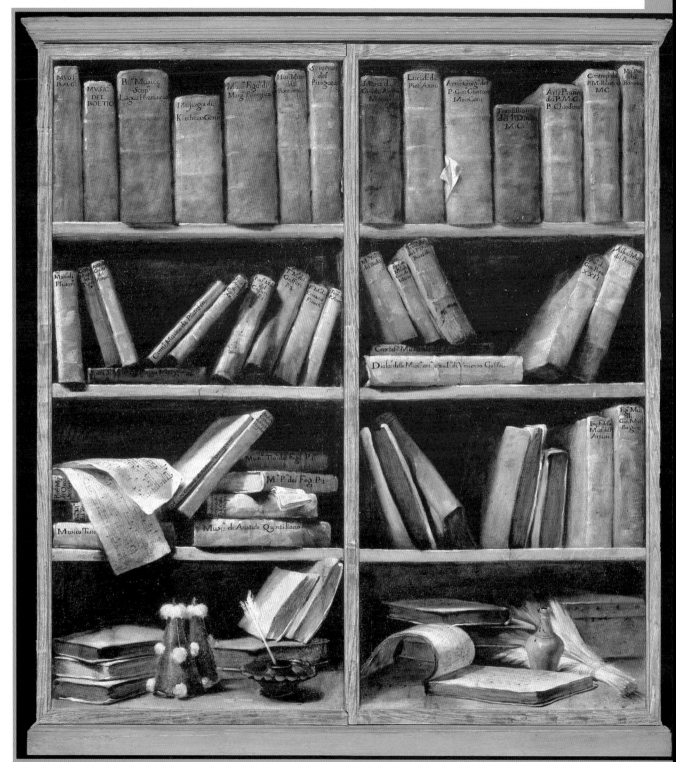

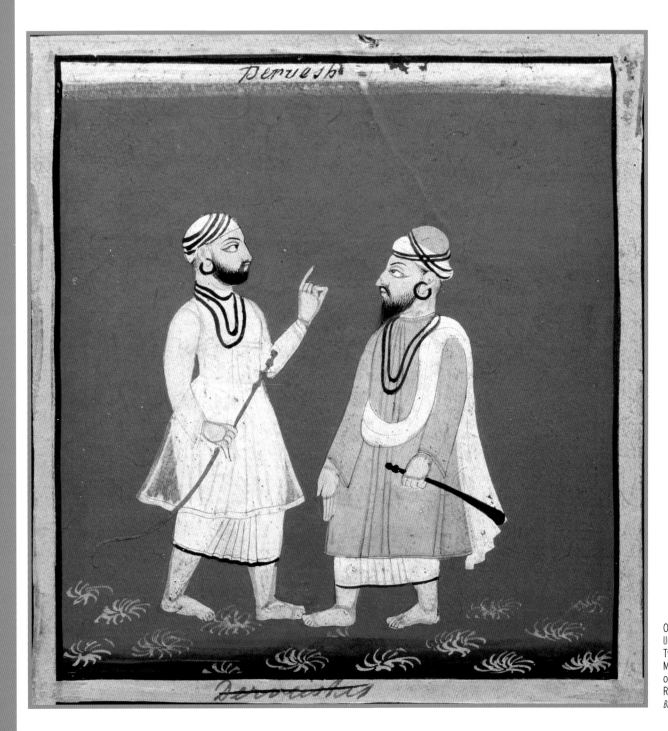

On right:
Sante Castignani per Alinari
Poster showing the opening of
the lyric opera "Rigoletto"
in 1991
Seat Archive/Alinari Archives, Florence

On left:
Unidentified Photographer
Two Dervishes, Religious
Mendicants, Udaipur, gouache
on paper by Indian School,
Royal Asiatic Society, London
Bridgeman/Alinari Archives, Florence

GRAN TEATRO LA FENICE

Domani Lunedì 10 Marzo 1851 RIPOSO.

Martedì sera 11 Marzo suddetto Recita XXXVIII.

PRIMA RAPPRESENTAZIONE DELL' OPERA

RIGOLETTO

Parole di F. M. PIAVE. — Musica di GIUSEPPE VERDI espressamente scritta.

PERSONAGGI	ARTISTI	PERSONAGGI	ARTISTI
Il DUCA di Mantova	RAFFAELE MIRATE	MARULLO Cavaliere	FRANCESCO DUKUNERT
RIGOLETTO suo Buffone	FELICE VARESI	BORSA Matteo Cortigiano	ANGELO ZULIANI
GILDA sua figlia	TERESINA BRAMBILLA	Il Conte di CEPRANO	ANDREA BELLINI
SPARA FUCILE, Bravo	FELICIANO PONS	La CONTESSA sua sposa	LUIGIA MORSELLI
GIOVANNA custode di Gilda	ANNETTA CASALLONI	USCIERE di Corte	ANTONIO RIZZI
MADDALENA, sua sorella	LAURA SAINI	PAGGIO della Duchessa	ANNETTA MODEST-LOVATI
Il Conte di MONTERONE	N. N.	Cori e Comparse, Cavalieri, Dame, Paggi, Alabardieri, Servi di Corte.	

La scena si finge nella Città di Mantova, e suoi dintorni. — Epoca il secolo sedicesimo.

Dopo l'Opera il Ballo grande Fantastico di GIULIO PERROT, riprodotto e diviso in 5 quadri dal Coreografo **DOMENICO RONZANI.** Musica dei Maestri Panizza e Bajetti.

FAUST

PERSONAGGI	ARTISTI	PERSONAGGI	ARTISTI
Il dottor FAUST, alchimista	GIUSEPPE BINI	VALENTINO, giovane soldato	CARLO CONTI
WOLGER, suo scolaro ed amico	LUIGI FRANZINI	MARTA, amica di Margherita	ANGIOLINA MORLACCHI
BERTA, madre di	COLOMBA REGINI	PETERS, suo fidanzato	LUIGI FRANZINI
MARGHERITA, fidanzata a	AUGUSTA MEYWOOD	MEFISTOFELE, genio del male	DOMENICO RONZANI

Studenti, Contadini d'ambo i sessi, Nobili, Cavalieri e Dame, Paggi, Guardie, Genii dell'aria, Spiriti angelici ed infernali, Streghe, Esseri fantastici, Un carnefice, Giudici, Birri, Popolo, ec. *La Scena è in Alemagna.*

DANZE. Atto 1. PASSO D'AZIONE FANTASTICO, eseguito dalla sig. **AUGUSTA MEYWOOD** ed accompagnato dalle prime Ballerine di mezzo Carattere.
 Atto 2. BALLABILE CARATTERISTICO, eseguito dai secondi Ballerini. - PASSO DI AFFASCINAZIONE, eseguito dalla sig. **AUGUSTA MEYWOOD E DOMENICO RONZANI,** Gambardella, Schiano, Casaloni.
 Atto 3. BALLABILE, eseguito dall'intero Corpo di Ballo. — PASSO a QUATTRO, eseguito dalle sig. A. MEYWOOD Gambardella, Casaloni e Amadeo.
 Atto 5. BALLABILE INFERNALE cui prenderà parte principale la signora AUGUSTA MEYWOOD.

Il prezzo del Biglietto d'ingresso effettive Austr. L. 3.—
Pei piccoli Fanciulli . " 1.50
Gli Scanni della Seconda, Terza, Quarta, Quinta, Sesta e Settima fila si vendono ad Austr. Lire DUE effettive al Cancello del sig. Marco Marangoni.

Tipografia Rizzi. Dal Camerino del Teatro il 9 Marzo 1851. *Si alza la Tela alle ore 8 precise.* L'Impresario G. B. LASINA.

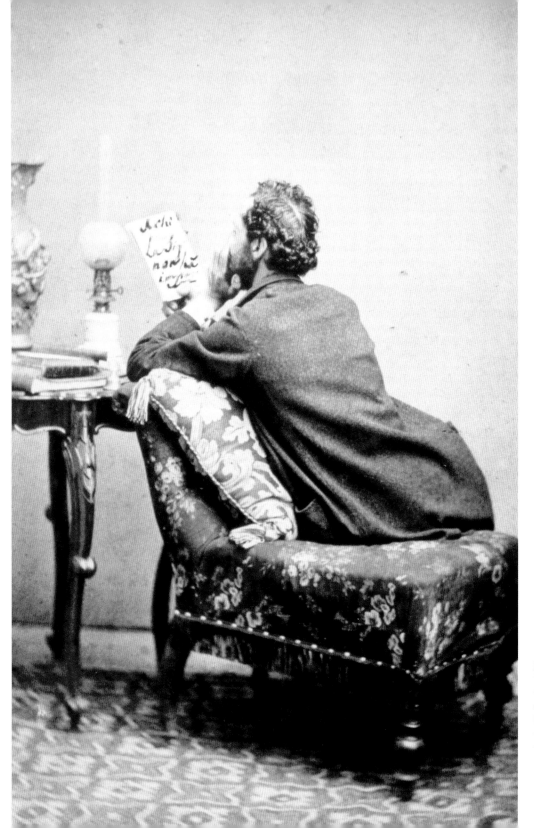

Unidentified Photographer
Man sitting, seen from behind,
leaning on the backrest of an
armchair and holding a piece of
paper, 1870 ca.
*Fratelli Alinari Museum of the History of
Photography-Malandrini Collection, Florence*

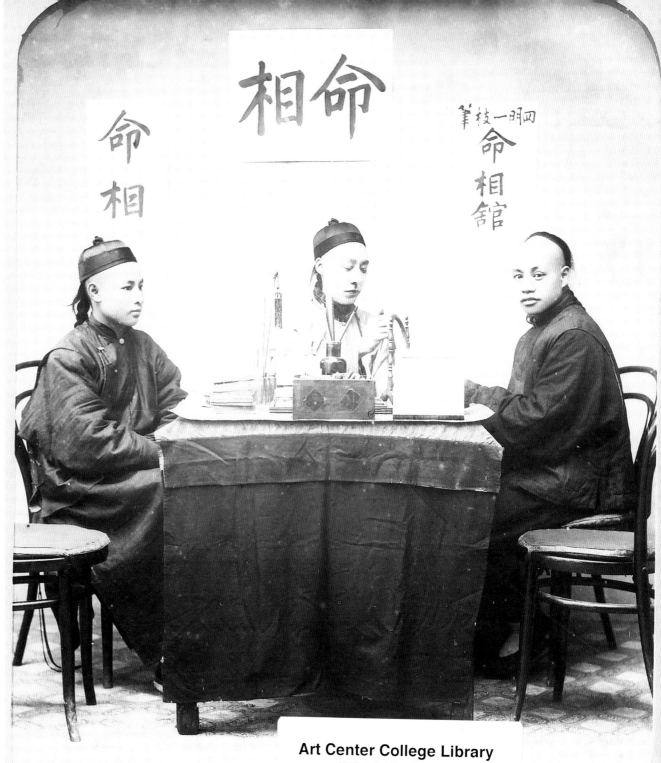

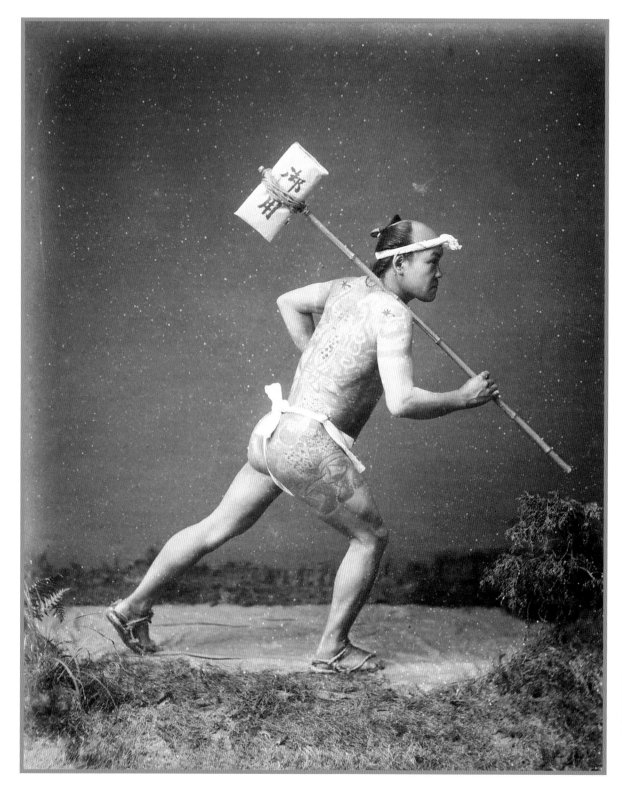

Unidentified Photographer
Portrait of a tattooed Japanese
letter carrier, 1870 ca.
*Fratelli Alinari Museum of the History of
Photography, Florence*

8 Mars, 1881.
41, Maitland Park Road, London. N.W.

Chère citoyenne,

Une maladie de nerfs qui m'attaque périodiquement depuis les dernier dix ans, m'a empêché de répondre plus tôt à votre lettre du 16ᵐᵉ février. Je regrette de ne pas pouvoir vous donner un exposé succinct et destiné à la publicité de la question que vous m'avez fait l'honneur de me proposer. Il y a des mois que j'ai déjà promis un travail sur le même sujet au Comité de St. Pétersbourg. Cependant j'espère que quelques lignes suffiront de ne vous laisser aucun doute sur le malentendu à l'égard de ma soi-disant théorie.

En analysant la genèse de la production capitaliste, je dis:

" Au fond du système capitaliste il y a donc la séparation radicale du producteur " d'avec les moyens de production ... la base de toute cette évolution c'est l'ex- " propriation des cultivateurs. Elle ne s'est encore accomplie d'une manière " radicale qu'en Angleterre ... Mais tous les autres pays de l'Europe occidentale " parcourent le même mouvement" (" Le Capital", édit. franç. p. 315)

La " fatalité historique" de ce mouvement est donc expressément restreinte aux pays de l'Europe occidentale. Le pourquoi de cette restriction est indiqué dans ce passage du ch. XXXII:

" La propriété privée, fondée sur le travail personnel ... va être supplantée par " la propriété privée capitaliste, fondée sur l'exploitation du travail d'autrui, " sur le salariat." (l. c. p. 340)

Dans ce mouvement occidental il s'agit donc de la transformation d'une forme de propriété privée en une autre forme de propriété privée. Chez les paysans russes on aurait au contraire à transformer leur propriété commune en propriété privée.

L'analyse donnée dans le " Capital" n'offre donc de raisons ni pour ni contre la vitalité de la commune rurale, mais l'étude spéciale que j'en ai faite, et dont j'ai cherché les matériaux dans les sources originales, m'a convaincu que cette commune est le point d'appui de la régénération sociale en Russie; mais afin qu'elle puisse fonctionner comme tel, il faudrait d'abord éliminer les influences délétères qui l'assaillent de tous les côtés et ensuite lui assurer les conditions normales d'un développement spontané.

J'ai l'honneur, chère citoyenne, d'être votre tout dévoué

Karl Marx

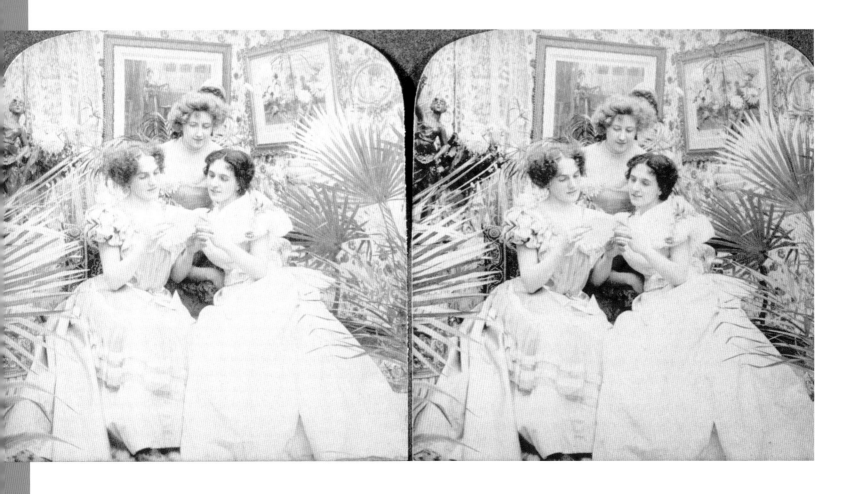

On left:
Underwood & Underwood; Strohmeyer &
Wyman Publishers
Portrait of three young women
reading a letter, 1899 ca.
Fratelli Alinari Museum of the History of
Photography-Palazzoli Collection, Florence

On right:
Unidentified Photographer
An Easter greeting card, 1910 ca.
Fratelli Alinari Museum of the History of Photography, Florence

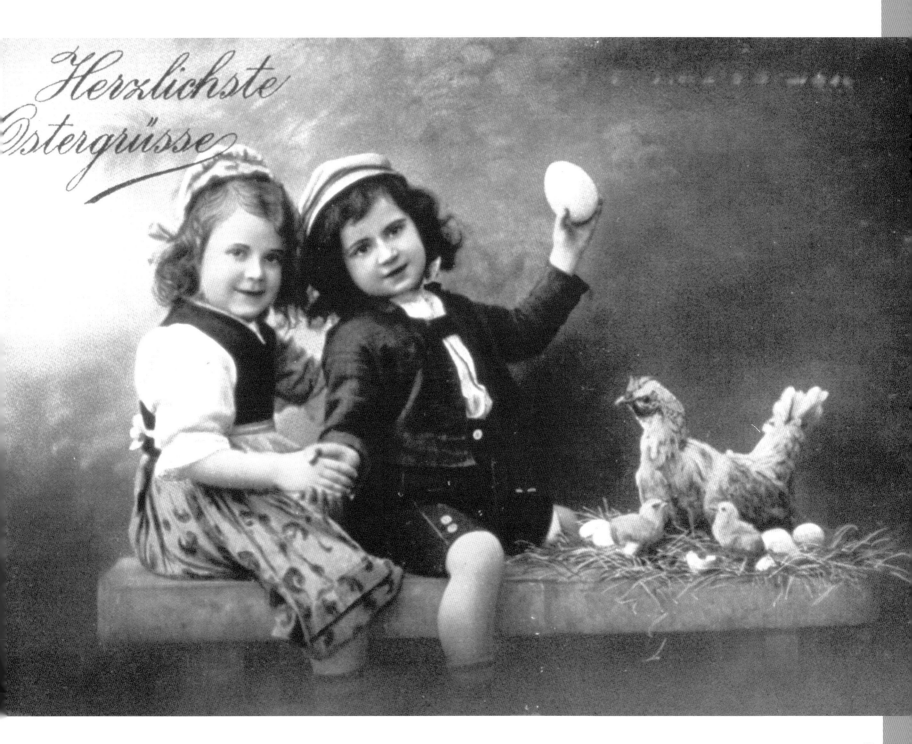

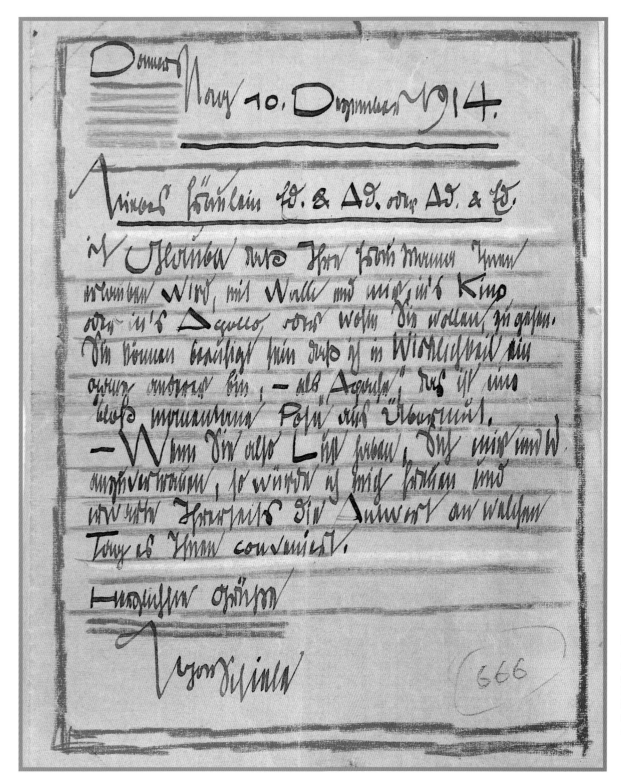

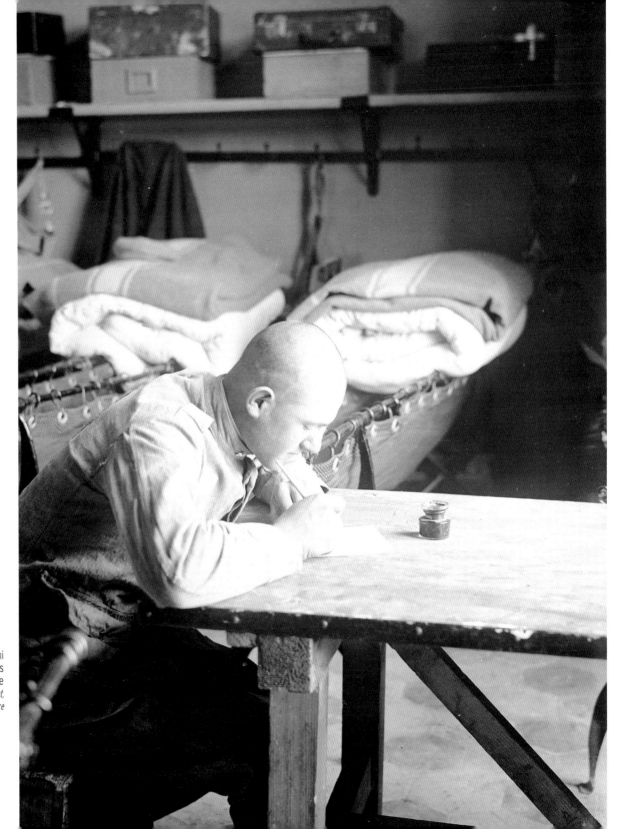

Armando Bruni
A soldier seated in the barracks
dormitory writes a letter home
Bruni Archive/Alinari Archives Management,
Florence

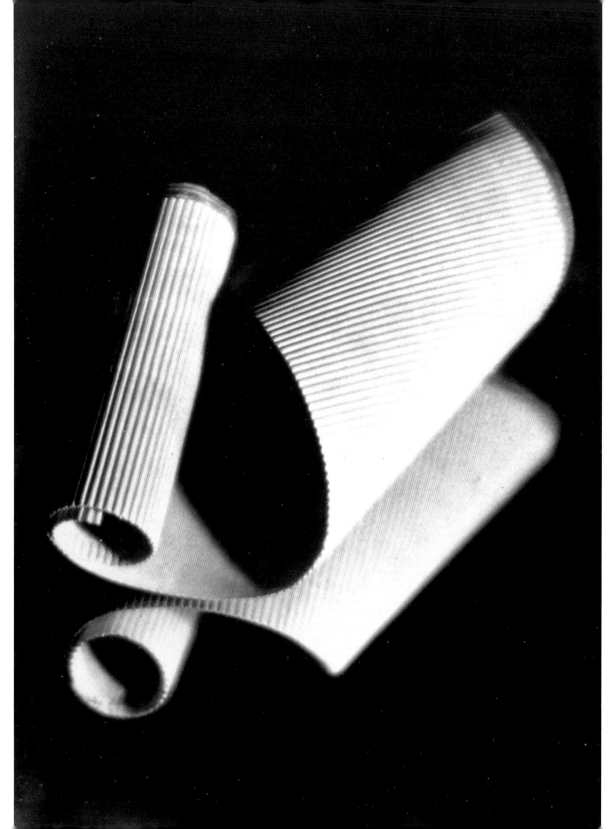

Giulio Parisio
"I don't know if you see what I mean". Rolled paper photographed on a dark background, 1935
Fratelli Alinari Museum of the History of Photography, Florence

STEPHAN FÜSSEL *translated by Douglas Martin*

GUTENBERG AND THE IMPACT OF PRINTING

We know that methods also existed in the Far East from as early as the eighth century for the multiplication of texts from woodcuts, from 1100 using clay letters, and after 1377 by means of the sand-casting process; but it was Gutenberg's related sequence of inventions involving casting and setting single metal types and printing from them in a press, that first created texts which were comparable in beauty to the finest manuscripts, and at the same time distributed them in unprecedented quantities. The possibilities

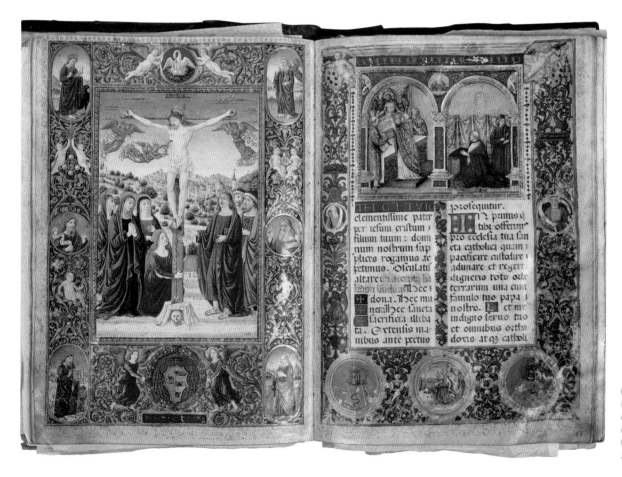

George Tatge for Alinari
Crucifix and lithurgic
celebration scene, miniature at
cc. 62 v. and 63 r. "Borgia",
Chieti Cathedral Treasures, 2001
Seat Archive/Alinari Archives, Florence

opened up by printing supported the educational trends of the late Middle Ages that had launched the aspiring European universities of the XIV and XV th centuries, promoted the spread of the ideas of the Italian humanists with their belief in a universal human capacity for education, whilst at the same time bringing about the preconditions for the Reformation of the Church and the popularisation of the contents of faith in the vernacular languages. Printing also heralded the birth of public opinion mediated through newspapers and the press, and prepared the way by circulating factual information as well as agitation and propaganda through pamphlets and broadsides.

Epics in verse form - an outward indicator of public reading - were no longer published, their place being taken by pocket editions of prose romances for private reading; and the first factual books on medicine and natural history, printed maps of Europe and the world, calendars and almanacks were circulated. Only fifty years after the invention, more than a thousand printing offices using the new technology were at work in some 350 towns right across Europe, and between 1450 and 1500 about 30,000 titles were published with a total estimated output of 9 million volumes. Contemporaries rejoiced that it was now possible for "everyone of moderate means to acquire a higher education".

The technical essentials of Gutenberg's invention remained unchanged for 350 years. The first modifications came in the nineteenth century with steam-driven cylinder presses, mechanical composition and manufacture of paper in continuous reels, but metal composition and the letterpress process held out until the middle of the twentieth century. Filmsetting and the offset process took over from that point until the scope of present-day electronic publication created a new technological environment. The communication revolution associated with Gutenberg's name, however, continues on its way.

The course of Gutenberg's life

The fifteenth century was an age of stagnation in politics and Church affairs; the emperor stood opposed to the imperial hierarchy, of whom the electors formed a particularly factious element. The imperial diet which met at irregular intervals revealed the emperor's dependence on the princes when it came to the Hussite and later the Turkish campaigns. The territorial overlords gained an ever more commanding position, and the free cities frequently invoked their special status under the law. Learning flourished, leading to changes in higher education and

...regnis per omne sccul[i]

ia. Auertit dominus. ā. All...

ixit insipicn[s]

ce suo: no e[st]

or

ozrupt[i]

et ab homin[es]

fca sunt in iniquitatibz:

qui faciat bonum.

Ocus de celo pro...

On left:
George Tatge for Alinari
Man holding a club, illuminated
figure of a manuscript, in the
Sanctuary of Sant'Anna in
Borgosesia, Vercelli, 1994
Seat Archive/Alinari Archives, Florence

On right:
Alinari
Illumination depicting Pilate sending
the inscription to be hung on the
Cross: "Jesus of Nazareth, King of the
Jews"; in the Codex De Predis (c.117v),
Royal Library, Turin, 1998
Alinari Archives, Florence

Cctrona.

Cttrona. cpro. fri. 7 bu. Elecr. bii matina. uuani. fto colicis. nocum. fto flattos. Qo qñant bnore: fri. uenuit mag. ca.7 sic. tnnenibs estati 7 ca. regioibs.

the foundation of universities in Cologne and Erfurt in 1389, Würzburg in 1402, Leipzig in 1409 and Louvain in 1425; jurisprudence and mathematical sciences were strongly promoted. The dominant intellectual current of the age was humanism, with its belief in universal educability and a new spiritual openness that tried to bring together Platonism and Christianity. Although only about six per cent of the population lived in towns, these grew in importance with the introduction of simple industries such as cloth and linen production, whilst the agricultural economy was in slow decline. The old Hansa privileges were being lost and new methods of trading were taking their place, which benefited the international trade fair centre of Leipzig and made use of merchant and private banking houses, particularly those of Augsburg and Nuremberg in southern Germany.

At the beginning of the fifteenth century, the city of Mainz had about 6,000 inhabitants. At this time of radical upheaval the city council enacted a new constitution, which was more strongly weighted in favour

of the right of the guilds to be informed and to participate at the expense of the old patrician class. In the quarrels between patricians and guilds the families of the "ancients" were several times forced to leave the city, and at other times they absented themselves in protest. The financial situation of the city developed so catastrophically during the 1450s that it had to borrow massively from the surrounding towns, and above all from Frankfurt. By 1456 the city was literally bankrupt and more or less in pawn to Frankfurt. At the same time Mainz, however, still retained its legal status as an imperial free city, whereas after the archbishop's war of 1462 it became a dependency of its archbishop and elector. The economic position of Mainz - which had been such a prosperous city in the fourteenth century - became ever more critical until it went into recession around 1450 with a drastic population decline. Immigrants were welcomed because of this underlying problem, and in 1436 new citizens were solicited with the offer of a ten-year break from taxes and levies. The local trades and occupations included woodworking and the timber-trade, river transport, farming and viticulture, and also cloth-weaving, wrought-iron and nonferrous metal crafts as well as goldsmithing.

No certain date of birth has been handed down for Gutenberg. In connection with the division of his father's estate in 1420, he was considered to have come of age, and - on the basis of different arguments - researchers have settled for various years fTom the range between 1393 and 1403. Since the turn of the century was accepted as the token year by international consensus in 1900, then this traditional argument allowed his 600th birthday to be celebrated in the year 2000. And as it was not uncommon at the time to name someone after the patron saint of their date of birth, then traditionally 24 June (St John's Day) has been the accepted birthday; but it is very probable - as the name Johann (or Johannes, or in Mainz dialect of the fifteenth century Henchen, or Hengin or Henne) was so popular and widespread - that the name-day connection is tenuous indeed. We can only speculate about Gutenberg's childhood and youth. At best we may suppose from his good grasp of Latin and his technical knowledge that he was well educated in a monastic school, probably followed by a spell at university (possibly in Erfurt). In the years 1434 until 44 Gutenberg lived in the important city of Strasbourg with approximately 25,000 inhabitants where he acted as a master in teaching goldsmithing and was working together with a few others in manufacturing mirrors, his first mass production.

A great deal of speculation has been caused by the secretive sounding phrase "Aventur und Kunst" which occurs several times in the documentation of his life in Strasbourg. A glance at the contemporary contexts in which the word is used, however, will show that "Aventur" does not indicate some colourful adventure from knightly romance, but rather a risky business "venture" in the modern sense. And similarly the term "Kunst" stood for skilful knowledge of handicrafts. Gutenberg is revealed here and in the following years as an inventive entrepreneur and technologist.

One of the conditions for his inventions was the spreading of paper in Europe. Paper, which had been

developed in China by the second century, did, on the contrary reach Baghdad and Cairo along the Silk Road by the tenth century, and with the expansion of Islam, extended over North Africa, Sicily and Gibraltar to reach Europe in the twelfth century. The first papermill in German lands was set up by Ulman Stromer in Nuremberg in 1390 and with it one of the essential preconditions for Gutenberg's invention fell into place, and an early instance of mass production was created.

Bringing the technical inventions together

Gutenberg's invention is as simple as it is ingenious: texts were broken down into their smallest components, i. e. into the 26 letters of the Roman alphabet, and by placing single letters in the right order a new, meaningful text would result. Texts had been copied over the centuries by writing them out completely and sequentially, or by cutting them equally completely in wood (text and illustrations were being cut in wood for such contemporary "blockbooks" as prayers, ars moriendi or cribs for sermons), but now only the letters of the alphabet had to be cut and supplies cast and they would always be available for setting up whatever text was chosen. His second brainwave was in effect as simple as it was technically revolutionary: instead of transferring the ink to the paper by rubbing as had been done for 700 years in Asia, Gutenberg used the physical action of the paper- or wine-press to transfer the ink from typematter to dampened paper with one even and forceful impression (see Plate 2, the first contemporary woodcut to show a press, dating from 1499).

Very many stages were naturally called for in the development of this apparently obvious and straight-forward procedure. Punches for individual letters, skillfully cut by goldsmiths, had been around for some time, and the engraving of sacred artefacts such as chalices and monstrances was a widespread technique. Casting methods were in use whether for bell-founding or coinmaking. It was a question of realising the idea by bringing together individual letters, and casting techniques, and finding the appropriate constituents of the typemetal. At the heart of Gutenberg's discovery stands the development of a casting instrument which allowed the casting void to be precisely adjusted so that identical supplies of each type could be cast. No original instruments have survived from the fifteenth century, and the so-called adjustable hand mould shown in the textbooks only reached that precise form some two centuries later, but the earliest types which do survive and the quality of Gutenberg's impression make it evident that some comparable casting instrument must have been part of the original invention.

To start with a letter was engraved on the top of a tall steel bar or cube. This bar carried a single character in deep relief and in mirror image; it was then struck by a hammer into softer copper so that a right-reading, deeply sunken letter resulted. This was now the matrix, which had to be correctly fitted into the casting instrument. Molten metal was poured in, and a single type cast, with the letter at its head in relief but again in mirror-image. As the casting matrix in harder metal could be used again and again, a theoretically endless supply of identical types of the same let-

ter and shape could be cast. The exact constitution of the first alloys is not known but may be inferred from later discoveries to have been about 83 per cent lead, 9 per cent tin, 6 per cent antimony and 1 per cent each of copper and iron; this compares with an actual find from the mid-seventeenth century in Mainz, where the lead content was markedly lower at 73 per cent and tin and antimony totalled 25 per cent (a composition which would have had the advantage of cooling more rapidly, allowing a higher rate of production).

Supplies of these singly cast types were then placed in compartmented cases where an ergonomic principle operated, in that the most frequently used letters had larger, well-positioned compartments close to the compositor's hand. The individual letters were then assembled in a composing stick, in which the lines could be "justified". For this purpose metal spacing material that was blind (i. e. below printing height) was introduced to equalise the space between the words and bring the lines out to equal length. These composing sticks were at first made of wood and later replaced by metal. Small groups of completed lines

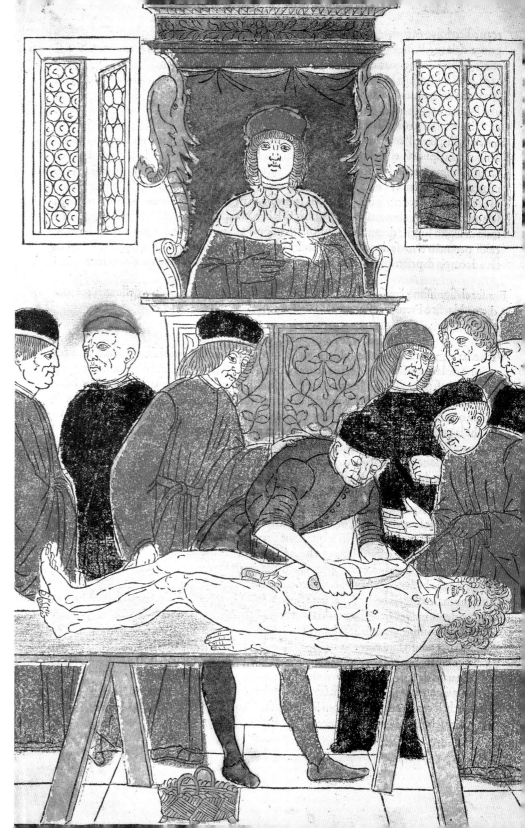

Mauro Magliani for Alinari
Fasciculo de Medicinae, Venice,
Zuane Printing House and
Gregorio de Gregori: Surgeon's
operation. Incunabulum by
Joannes de Ketham,
Civic Library, Padua, 1994
Alinari Archives/Bridgeman, Florence

were transferred to a galley, a stable wooden tray in which they could be made up into column or page depths. These could be brought out to the correct depth if needed by "leading", or adjusting the space between lines, using further strips of blind spacing material. The finished pages were placed in correct relationship to reach other, and locked up into a "forme" or frame to fit the bed of the press.

The typesetting was then inked using mushroom-shaped leather balls (the printing ink developed by Gutenberg was made from soot from lamps, varnish and egg-whites). The paper to be printed had been dampened so that it would take the impression from the type better, and was positioned on a number of pins within a hinged tympan. A frisket, which in turn hinged over that, had a cut-out corresponding to the type area, and otherwise protected the margin of the paper from coming into contact with the forme and possibly being soiled. The frisket was closed and then the tympan with the frisket and paper was folded above the forme which rested on the bed of the press. The bed was drawn in under the platen, which was brought down by a heavy pull on the lever to take an impression. This first impression was "backed-up" on the other side of the sheet, with the pin-holes keeping

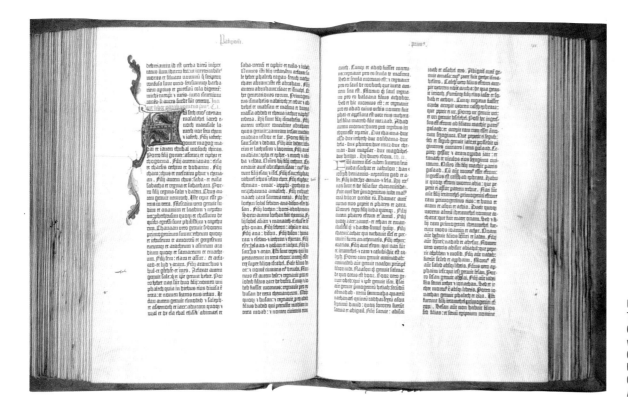

Unidentified Photographer
Two folios (vellum) from a Gutenberg Bible, printed in the workshop of Johannes Gutenberg in 1455, Universitatsbibliothek, Gottingen
Bridgeman/Alinari Archives, Florence

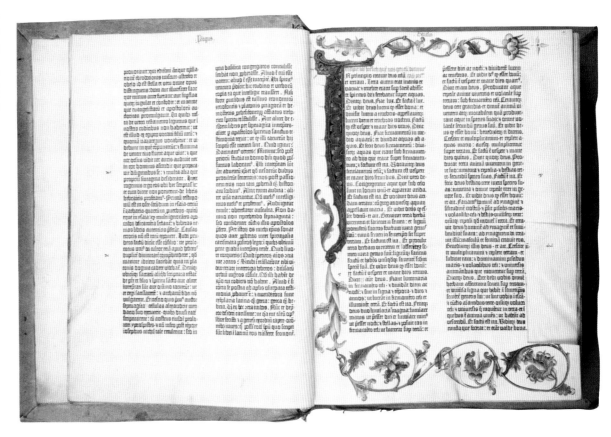

the registration exact so that the lines of type on both sides of the sheet corresponded. Sheets of various sizes could be printed, in the early days a page at a time, and later two, four or eight pages together, and allowed to dry before the other side could be printed, and later folded into sections. Careful "imposition" ensured that the pages fell in the right order when folded into 16-page sections for sewing.

Early printing was produced in black only as a rule, and all special features such as illuminated initials, coloured page headings, illustrations, as well as rubrication (lit. writing in red) had to be added later by hand. As a result many early printed books can be mistaken for manuscripts at first glance, since their decoration was added individually by hand. None of the 49 surviving copies of the Gutenberg Bible resembles another, for each has its own illumination and finishing touches. At first woodcuts were not printed together with typematter, as it was difficult to get the inking and impression right for printing from wood and metal at the same time. In the earliest instances, text and illustrations were usually printed in two separate operations,

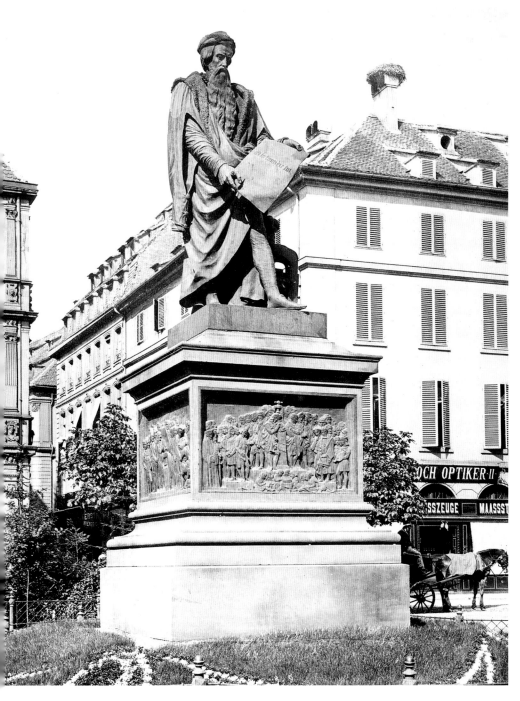

although this could bring its own problems when it came to register. This is well illustrated in *Der Edelstein*, the fable collection printed by Albrecht Pfister in Bamberg in 1461.

Whereas it would have been theoretically possible to make do with two sets of 26 characters one each for the capitals and lower case - Gutenberg was evidently concerned to imitate the manuscript as faithfully as possible, in that he reproduced double-column setting and the same marginal proportions and went to great trouble to match the look of the page en masse. To that end he cut and cast a total of 290 different characters: 47 capitals, 63 lower case, 92 abbreviations, 83 ligatures or combined letters and 5 punctuation marks. The ligatures, such as ff, fi, ffl, ft, saved space by being cast on a single body. Abbreviations and contractions taken over from Latin manuscript usage for prefixes (pro, prae, per), case-endings (um, am, as) and doubled letters (mm, nn), were also great space savers. All these, and the width variants available for many lower-case letters, helped the skilled compositor to produce evenly spaced lines and a wonderfully close and evenly spaced page. At the same

Unidentified Photographer
Gutenberg's statue, work by
David D'Angers, in the
homonymous square of
Strasburg, 1890 ca.
*Fratelli Alinari Museum of the History of
Photography, Florence*

time it becomes apparent what high demands were placed on the compositor's knowledge of Latin. Some 100,000 types would have had to be cast for the compositor's work on the Gutenberg Bible. This allowed every detail of a manuscript text to be followed, whilst surpassing it in accuracy and quality. The first experiments and attempts at printing in this typeface must have related solely to Latin texts, for many of the abbreviations provided were only called for in Latin.

Gutenberg's early pieces of printing fall into two main groups, on the one hand mass productions such as indulgences, calendars and vocabularies, and on the other hand that great masterpiece of 1282 printed pages, the Latin Bible. Unquestionably one of the most lucrative commissions for early jobbing printing was to print massive numbers of indulgences for the Church up to 190,000 copies. These indulgences, which became such a bone of con-

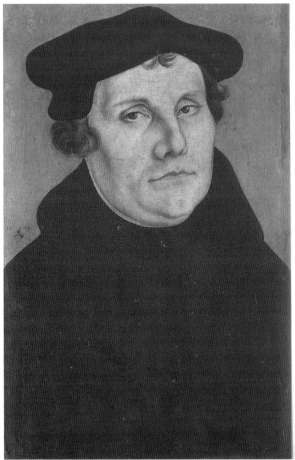
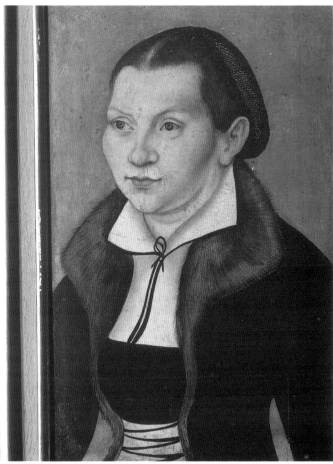

Nicola Lorusso for Alinari
Portraits of Martin Luther and his wife Katharina Von Bor by Lukas Cranach the elder, Uffizi Gallery, Florence, 1990
Alinari Archives/Bridgeman, Florence

tention for the Reformers, played a material role in fifteenth-century religious practice and were extensively circulated in manuscript.

Close textual analysis of the Latin Bible and the study of individual habits in handling abbreviations let' us conclude that there were four different compositors at work when typesetting began, and six as production reached a more advanced stage. Examination of inks through electron spectrography has confirmed these numbers. At least half a year has to be allowed for the casting of a supply of 100,000 types, and the typesetting would have extended over about two

56

years. At the height of production at least twelve printers would have been teamed with the compositors to keep six presses busy, and other helpers would have been needed for ink making and paper handling. To print 180 copies of 1282 pages would have involved 230,760 passes through the press, which in turn would require at least 330 working days. Allowing for the fact that the medieval working year had only about 200 days (because of the large number of religious festivals) and that only four presses were operated to start with and that there were bound to have been teething troubles, it is certain that typesetting and printing would have taken more than two years. Whereas a scribe would have worked a whole three years on a single copy of the Bible, it was now possible to produce 180 copies in the same time, 40 on vellum and 140 on paper. The paper imported from Italy would have cost about 600 gulden, the vellum (i. e. the skins of 3,200 animals) perhaps 400 gulden.

It provides guidance - using in each base a standard outline for the foliage - on how different colourways may be used: a soft raspberry red on one side of the leaf and a complementary slate green on what the writer calls the "turnover" side; alternatively a light blue may be paired with a deep red or a rather powdery-looking gold colour. The dark red was obtained from ground brazilwood to which lye, chalk and alum were added. This is brighter than the carmine in use in the high Middle Ages which had a heavier consistency. The green hues such as mountain green or slate green were derived from malachite, and shaded down to a sap green with a vegetable varnish

of uncertain constituency. The gold coloured tint was achieved through a mixture of mercury, tin, sal-ammoniac and sulphur. This gold colour is more reserved in effect than the genuine gold leaf or powder used where boldness and contrast were required instead. Fine brush shadings and accents in lead white conveyed modeling and surface detail.

Unquestionably one of the most lucrative commissions for early jobbing printing was to print massive numbers of indulgences for the Church. These indulgences, which became such a bone of contention for the Reformers, played a material role in fifteenth-century religious practice and were ex1ensively circulated in manuscript.

The spread of printing

Part and parcel of the phenomenon of Gutenberg's invention was the incredible speed with which it spread throughout Europe, whilst achieving astonishing quality in the earliest printing to come from each and every centre. At first the new technology was free to develop without regulation by governments, princely houses or the Church, nor is there any evidence that any restrictions were imposed by the guilds or others. A Bible with 36 lines had been printed before the close of the 1450s in Bamberg, from which city Ulrich Boner's Der Edelstein carries a firm completion date of 14 February 1461. Its printer Albrecht Pfister issued the most significant document of early humanism in Germany, Johann von Tepl's Der Ac:kermann aus Böhmen, from the same workshop. Johann Sensenschmidt was at work in Bamberg

by no later than 1481, printing a Missale Benedictum (31 July 1481) and further liturgica.

The importance the humanists attached to their own creative task in the educational field led them to ask a lot from the illustration and technical presentation of the printed works they published. These had not only to be textually accurate but also to correspond in outward appearance to their inner word. These requirements placed great demands on the training of compositors, proof-readers and publishers. A large number of testimonies from printer-publishers have come down to us pointing out how much care has been lavished on the foldless printing of a text. The humanists expressed their views on the prospects printing offered for popular education. It facilitated:

- The issue of classical texts in editions and anthologies which enabled their implicit "wisdom" to be shared.
- The spread of knowledge (as an educational task) through affordable and accurate texts in convenient format.
- A sound basis for university teaching and research.
- The preservation of international and national manuscript treasures.

In German-speaking lands it was Erasmus of Rotterdam above all who, in his polemical letters, reprimanded with biting satire a new generation of scholastics who had failed to encounter the classics on creative terms or to understand the enlightened impulse that lay behind humanitas.

Incunabula

From the first books of Gutenberg up until 1500 - the year laid down on purely bibliographical grounds for the end of the incunabula (Lat. incunabula, cradle) period - some 30,000 different publications appeared that are still traceable today. Eighty per cent of these were written in Latin, the obligatory European language of the Church and the learned community. Naturally, this had one tremendous advantage for the many printing offices spread right across Europe, in that their marketing area was not confined to a single narrowly encircled territory. That is why the Frankfurt book fair, for example, developed at so early a date into an emporium for books from France, the Netherlands and Italy.

Communication

Communication changed radically in the fifteenth century. After centuries of restriction to oral discourse, the sermon and the manuscript, new possibilities for the multiplication of religious and secular knowledge were now opening up because of the woodcut and the manufacture of paper in Central Europe.

Leaflets and News

Broadsides with sensational news, such as the latest information concerning theatres of war, freak births or glittering occasions of state, commanded a wide circulation. These were generally called "Newe Zeytung" after their main heading, and gradually the Middle

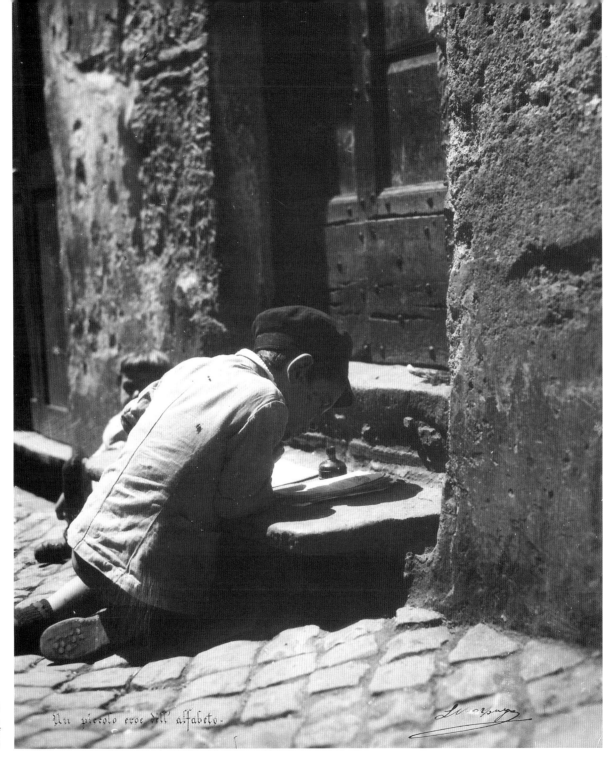

Luciano Morpurgo
"A little alphabet hero", 1920 ca.
*Fratelli Alinari Museum of the History of
Photography-Morpurgo Donation, Florence*

Un piccolo eroe dell' alfabeto.

High German term "Zeitung" (at first signifying just "news" or "tidings") gave its name to a new genre or medium. From the outset, this word was often qualified by an adjective such as "alarming", "happy" or "new". In contrast to the periodical press which first surfaced in the seventeenth century, these news-sheets were confined to a single topic and were aimed in each case towards a specific public. Most "current news-sheets" consisted of one news item usually containing a woodcut, and not always one intended for the purpose - and a rhyming text in two or three columns purporting to be an eye-witness narrative. Without this widespread and popular medium, we would be at best ill-informed about many fifteenth- and sixteenth-century events, including certain natural catastrophies, legal proceedings, the campaigns against the Turks or the early history of the Thirty Years War. Many of the ruling houses exploited this new medium and commissioned writers to feature popular entertainments such as royal weddings and also to report on plans for the call to arms and the conduct of war. Emperor Maximilian I (1493-1519), whilst still regent, began to deploy this means of influencing public opinion. Quite a few publicists loyally disposed towards the empire supported his measures through the journalistic manipulation of natural occurrences.

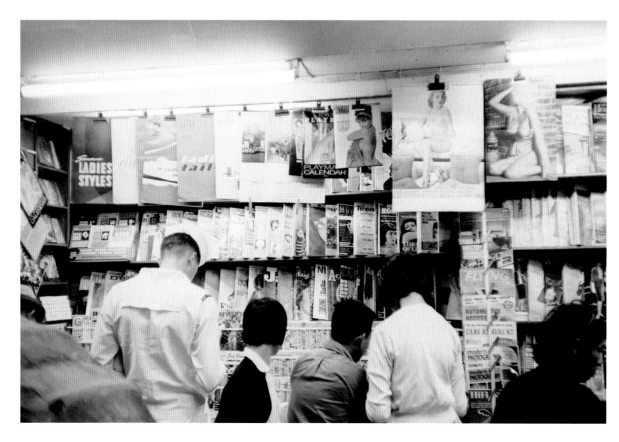

Fosco Maraini
Newsagent in Hong Kong, 1960 ca.
Fosco Maraini/Gabinetto Vieusseux
Property © Fratelli Alinari, Florence

Luther and the Reformation

The total of 18 German-language Bibles before Luther is a remarkable one, and if their impact was restricted, then this was largely due to high prices, outmoded language, and a word-for-word approach to translation that adhered too closely to the Latin model, blurring comprehension and garbling sense. These German versions were only really accessible to those who could have read the Latin text in any case. Added to this - as the Church pressed its claim to be the sole interpreter of the scriptures - the necessary incentive to purchase these editions was lacking.

It was not only Luther's own writings that were printed as leaflets of four, eight or sixteen pages, but also those of his fellow combatants and supporters. The pamphlets of Ulrich von Hutten (1488-1523) or Hans Sachs (1494-1576) call for special mention.

It follows that these leaflets have a fundamental importance for the study of the intellectual background to the Peasant's War of 1524-25. The leaflet containing the Zwölf Artikeln aller Bauernschaft was distributed through a massive first printing and numerous reprints.

In the first thirty years of the sixteenth century more than 9,000 pamphlets appeared, and with the Reformation, this rose to represent a 17 per cent share of total production by title after 1517. Within a year the peasant's "twelve articles" had appeared in over 24 editions from 18 printers in 15 different towns. This had the effect of a seven-fold increase in its share of the market for vernacular texts between 1519 and 1522, from which the mounting circulation of its contents may be inferred. Even assuming that editions of only 500 copies were the norm, the public they reached would have been disproportionately greater, for leaflets were read out and discussed in many places within each community. We know that Luther's Reformational hymns were first circulated in editions of 400 copies, which were then announced before public services so that the faithful could have access to them. There is a Reformational flyer of 1524 demonstrating just how flexible this practice was, which opens with the paradoxical sentence: "Dear reader, if you can't read, then find a young man who can read this text to you." The spread of Reformational ideas was achieved through printing, but their impact was relayed to wider audiences with the spread of these texts from the pulpit and through song.

Conclusion

Gutenberg had grasped that what was practical in the fourth decade of the fifteenth century such procedures as impressing stamps into clay or tooling bookbindings or printing fabrics, the engraving skills of goldsmithery and the casting techniques used in bellfounding, and harnessing the power of the wine- or paper-making press to print or impress - could lead to an epoch-making new process, whereby he could cast virtually unlimited numbers of identical letters in lead, from which he could then print at will, and so create a means of multiplying information such as no earlier age had enjoyed.

John D. Meyer, Ph.D.

The Briefest of Histories of Print

Printed material, whether in the form of books, newspapers, magazines, posters, or supplementary advertising, has enjoyed a preeminent position in the history of mankind. Print has been and is used as a means to disseminate ideas, record discoveries, communicate current events, entertain, and inspire. It has been central to the way in which humans communicate for many centuries. The last two decades have seen the biggest change in human communication since Gutenberg invented movable type. The ever-expanding array of electronic technologies has forever altered the way human beings exchange ideas, news, and events. A commonly heard statement today is "When you change the way people communicate, you change everything." This might be viewed as a modern version, with regard to the impact on human communication, of "The pen is mightier than the sword." There is naturally both concern and curiosity as to what this radical change in communication will mean for the future. How is print affected and what role will printed matter have in this digitally oriented set of communication media? Nicholas Negroponte of MIT has cast the issue as one between bits and atoms; i.e., material communication composed of atoms versus massless electrical signals.

It would be easy to focus on aspects of change that have expanded individual capability to create and distribute content. For example, a single person may take all of the photographs, completely lay out a book including choice of typography, and contract as an individual with a print provider to have the book published. This remarkable change was foreseen with the advent of desktop publishing. Let us look at how we got to this point. A useful perspective is to look at the way information has been coded or, to be more precise, encoded. History is clear that language preceded writing; and writing is an encoded form of the spo-

Luigino Visconti for Alinari
Egyptian architectural fragment decorated with the cartouches of king Amenophis IV,
Egyptian Museum, Turin, 1995
Alinari Archives/Bridgeman, Florence

ken word. Writing evolved from symbols, pictures into letters that had specific sounds associated with them. This was an enormous step in human communication; but the means of distribution were onerous. The only way to reproduce a text or a picture would be to employ those skilled in the art of copying. This, over time, was raised to a high art exercised with great skill. Everything was to change in the fifteenth century with Gutenberg's invention.

Gutenberg mechanized the production process. With inexpensive reproductions produced in volume, the ability to distribute and to disseminate ideas began to grow rapidly. Gutenberg spawned the field of typography and today the practitioners of that art are memorialized by their typefaces; e.g., Bodoni, Garamonde, … Note that the encoding had not changed. Writing could now be produced by a manufacturing process. As technology became available the process grew in sophistication. One notable event was the invention by Ottamar Mergenthaler of the linotype machine which cast lines of typography in lead. Thomas Edison described this machine as the eighth wonder of the world. Invented in the nineteenth century, hot lead linotype machines survived well into the twentieth century. The zenith of the mechanized production of typeset text was reached in the form of the phototypesetter that was soon replaced by the image setter. These devices produced lithographic film with fully typeset text ready to make offset plates, but the text was still being replicated from master representations.

The decade of the seventies saw the invention of the

metafont design system by Knuth of Stanford University. Everything was about to change. Knuth's technology defined typography in geometrical terms known as outline fonts. The letter "a" in Times Roman became a set of lines and curves joined together that transcribed the outline of the typeface. Writing was now mathematically defined. Coupled with the advent of page description languages (Postscript being the most notable example), desktop publishing was brought into being. The production of typeset text was a matter of computation which even, by typographical standards, low-resolution printers [300 dpi] could accomplish reasonably well. The quality of a typeface was determined by the reso-

Unidentified Photographer
Base of a marriage scarab of Amenhotep III and Queen Tiy, engraved stone, Louvre Museum, Paris
Bridgeman/Alinari Archives, Florence

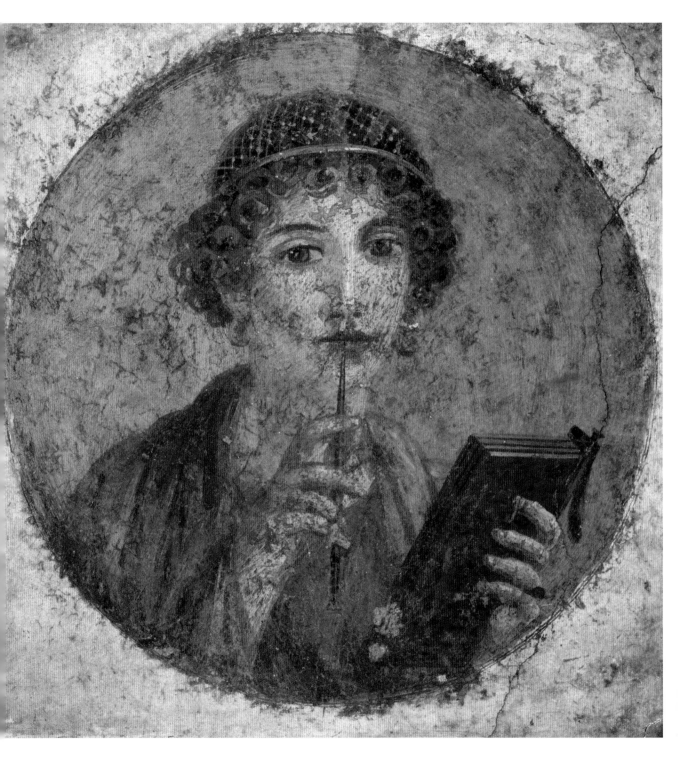

Luciano Pedicini for Alinari
Roman mural depicting Sappho,
Museo Archeologico Nazionale,
Naples, 1990
Alinari Archives/Bridgeman, Florence

lution of the printer and the font filling algorithm which placed the printed dots within the outline so as to fill it as precisely as possible. Early implementations were slow due to computational limitations, but these soon gave way as desktop machines relentlessly increased CPU (central processor unit of a computer) speed and inexpensive memory became even more inexpensive with every year. Typography had become "digital" which means amenable to computation and viewable by any raster imaging device whether electronic display or inexpensive laser, inkjet, thermal transfer, etc., printer.

At the outset, desktop publishing excited great expectations one of which was that an individual could publish a book; e.g., from the desktop all the way to the offset press. This did not happen immediately for the single reason that color images were difficult to reproduce and, in the decade of the eighties, color reproduction was a domain of the specialist. Even today, a certain mystery surrounds the process of color separation and color correction leading to high-quality printed images. The transformation of the creative arts was not complete. Typography and layout were now computational, but not color. From the very beginning color has been defined by its hue, its intensity or colorfulness, and its brightness. These characteristics were controlled by a simple means: the concentration of pigment or dyes employed in the inks or paints. More intensity meant more colorant. This is a very basic measure and amounts to a form of encoding color information. Coupled with the name for the color which generally specifies its hue, paints and dyes could be manufactured in a vast array that

would satisfy the most discerning customer. Commercial printers began using color inks to reproduce pictures and photographs and concurrently developed instruments to directly measure the intensity of a printed color. These instruments known as densitometers detected and measured the reflected light from a printed ink film which enabled the press operator to adjust the ink film thickness accordingly. Modern commercial printing, whether offset, rotogravure, and flexography all employ this means of control. Nonetheless, it is still the same encoding that has been used from the beginning.

The advent of low-cost digital color printers toward the end of the last century produced a challenge to this form of encoding. The need was to communicate color in computer systems such that a print file could be sent anywhere in the world and its information would be sufficient to generate the print intended by the sender. To accomplish this, colorimetry, which is the scientific measurement of color based upon

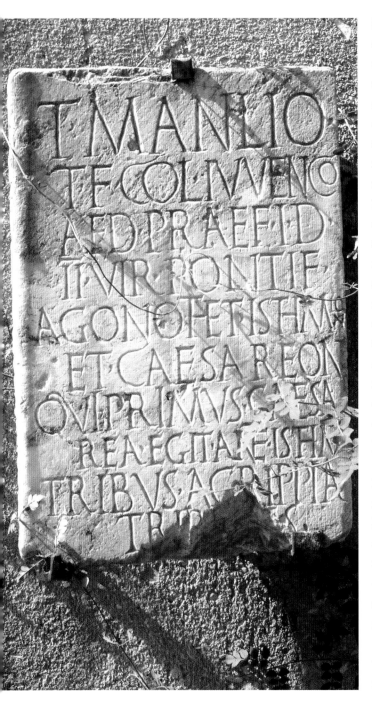

On right:
Mauro Magliani for Alinari
Mosaic showing a scene of
fighting gladiators, detail of a
fight between two gladiators,
Galleria Borghese, Rome, 1998
Alinari Archives, Florence

human visual variables, has been employed. A colori-metric specification which will include the nature of the viewing conditions (the specific light being used to view the print) is capable of providing this degree of accurate communication. This was the second encoding step for color information. Color was now specified in mathematical terms and computational methods could be applied. A wide range of algo-rithms, drawn from research in human vision, could be applied to colorimetric information to adjust the data for aesthetic appeal or for a physical change such as a different viewing illuminant. A closest visual match for an unprintable color can be defined by an algorithm and the degree of difference in the visual response can be calculated. As for text, the encoding of color information into a mathematically tractable form has had profound effect. The speed with which digital photography has come into being was due in no small part to the use of colorimetrically defined data standards, so that photographic files would be easily interchanged and the information confidently processed and printed.

It is seldom that a single event contains all the ele-ments of change that it produces. The world of print has been dramatically affected by a combination of events; namely, the mathematical encoding of all the information, the availability of high-speed desktop computers and very low-cost memory in large amounts, and now, with the aid of compression algo-rithms, the ability to communicate at speed around the world. This encoding of printed information is very flexible and can be applied equally to electron-ic displays as well as to all forms of printed media.

On left:
Alinari
Fragment of a stele from the
Roman Era, Archeological
Museum, Corinth, 1990
Alinari Archives, Florence

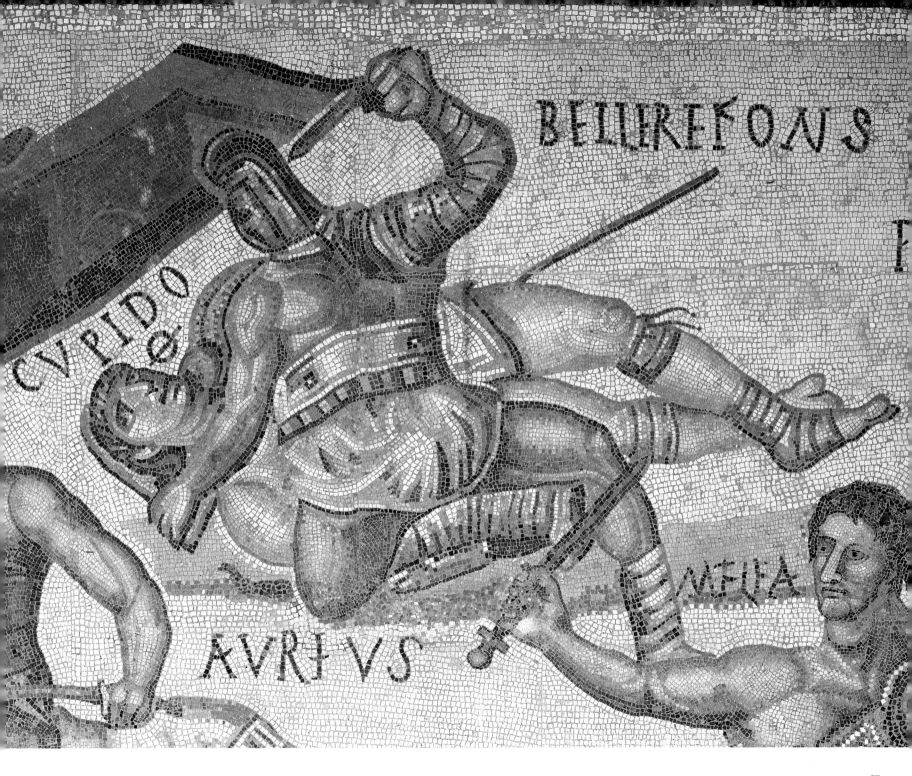

The encoding will support whatever level of quality that the output medium can provide.

The future of print is, therefore, directly connected to the future of electronic communications. In some cases, it will compete and, in other instances, supplement and expand the pervasive electronically driven world of communication. The Internet, in particular, has changed the world from large groups of people into vast numbers of individuals. The flexibility of electronic technologies and mathematical encoding can provide customized, personalized information

George Tatge for Alinari
The Camarlingo and the scribe in their Office, tablet preserved at the State Archives of Siena, 1995
Alinari Archives/Bridgeman, Florence

Fosco Maraini
Character, 1985 ca.
Fosco Maraini/Gabinetto Vieusseux
Property © Fratelli Alinari, Florence

on demand. Print is now an integral part of modern communication and there are no barriers between the different forms. Modern digital printing from consumer to the commercial provider is capable of great quality and personalization. It will co-exist with its electronic counterparts as it establishes its unique capabilities and carves out its own place.

Daniela Cammilli for Alinari
The Family Tree, panel by Beato
Angelico, part of the Silver
Coffers of the Church of
Santissima Annunziata in
Florence, Museum of San Marco,
Florence, 1990
Alinari Archives, Florence

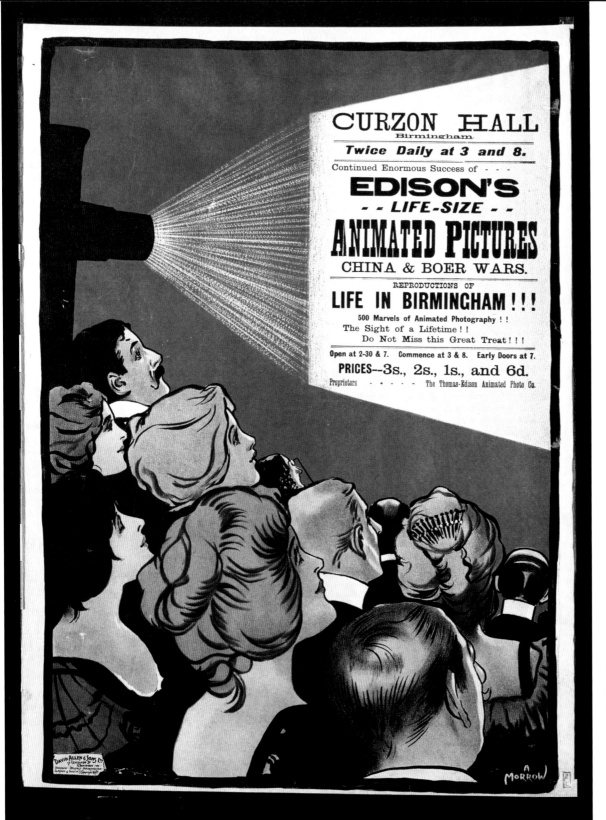

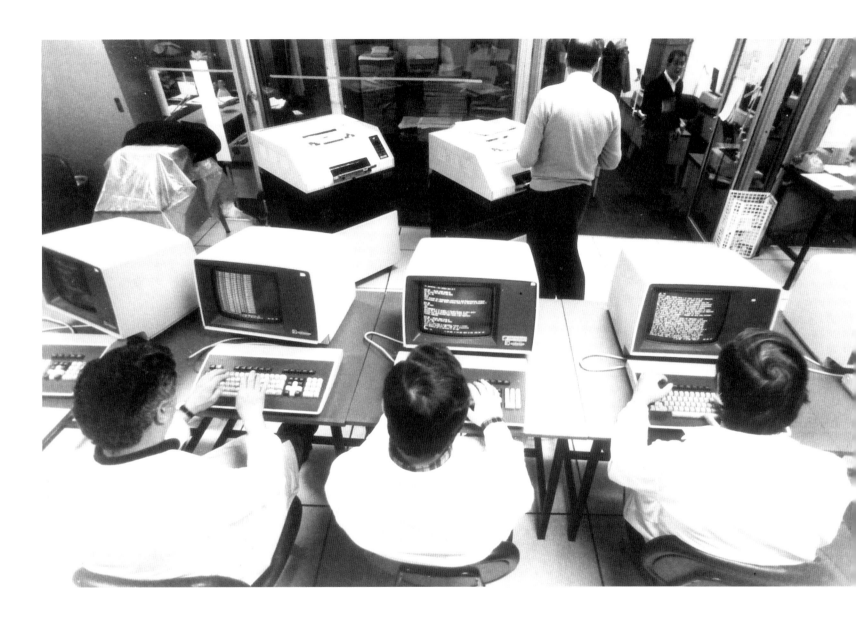

Team
Technicians in front of
computers and other equipment
in a laboratory, 1975 ca.
Team Archive/Alinari Archives, Florence

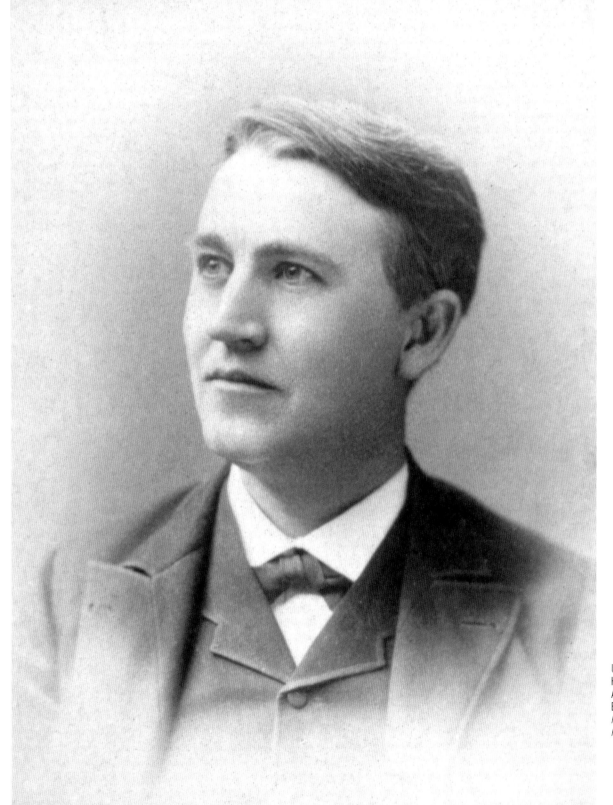

Unidentified Photographer
Half-length portrait of the famous
American inventor Thomas Alva
Edison, 1880 ca.
*Fratelli Alinari Museum of the History of
Photography, Florence*

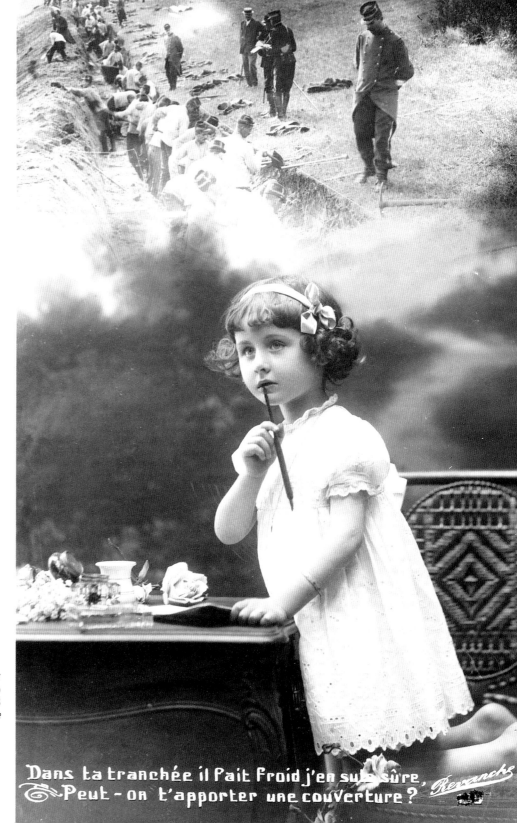

Unidentified Photographer
A little girl contemplates what to
write in her letter, 1914 - 1918
Roger-Viollet/Alinari Archives, Florence

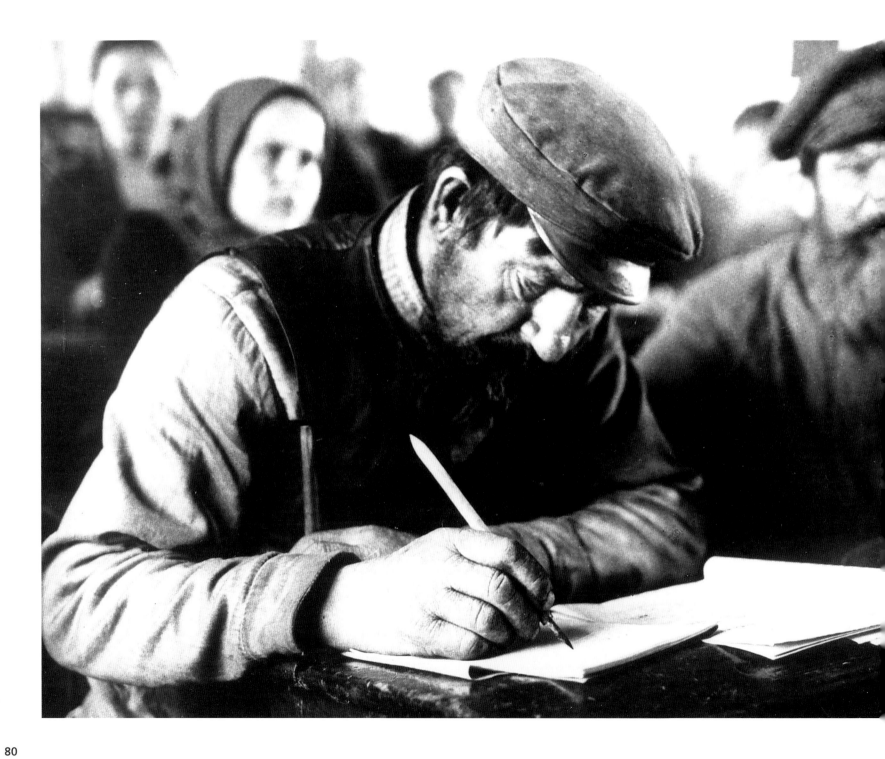

What is colour?

Our world is bursting with colour, isn't it? But actually colour is nothing but a sensation interpreted by the brain: it is not an intrinsic property of any object. Colour is a character of light, and what we commonly call "light" is only a narrow band of wavelengths between 400 and 700 nanometers in the electromagnetic spectrum, which also includes radio waves, microwaves, infrared and ultraviolet light, X-rays, and cosmic rays.

The particular colour of a surface results from selective absorption and reflection of the colours composing white light. Red objects reflect the red portion (longest wavelengths) and absorb all the remaining colours (shorter wavelengths, like greens and blues). More complex colours occur when different amounts of light are reflected across the entire visual spectrum. Purple, for example, contains both red and blue components. The surface may change colour when the illuminating light is not "white": an apple can appear gray if the illumination contains only green wavelengths (because green light is not reflected).

The human eye has four types of light receptive

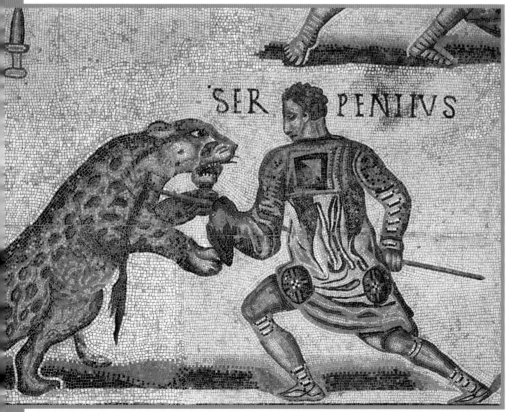

Mauro Magliani for Alinari
Detail of a mosaic of a Gladiator Fight, originally from Torre Nuova, Borghese Gallery, Rome, 1998
Alinari Archives, Florence

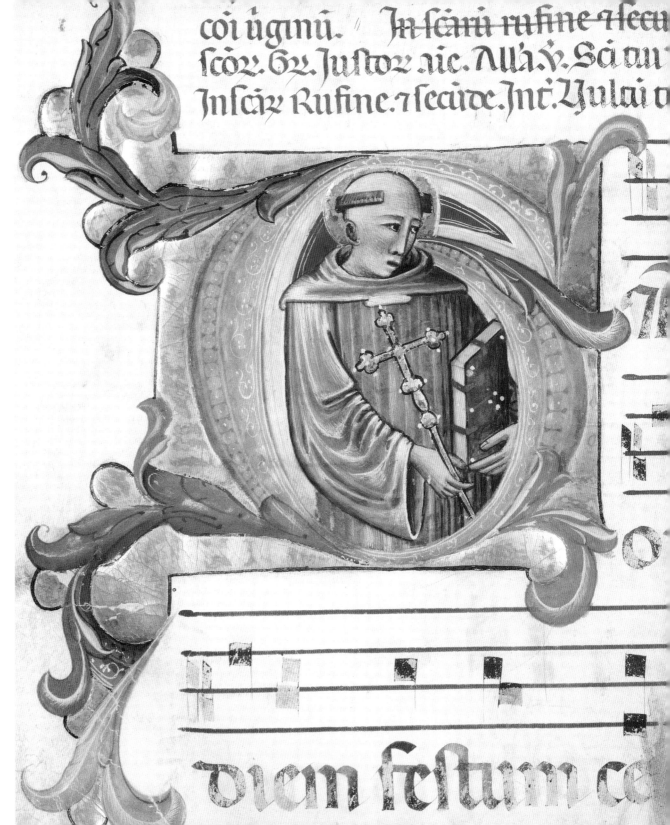

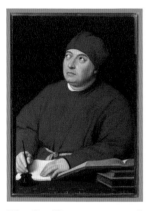

cells on the retina, called rods and cones because of their shape. Rods provide monochromatic vision under very low-light. Cones let us see the world in colour. There are three different types of cones, each sensitive to a different band of wavelengths. The "red" response peaks at about 580 nanometers, the "green" at 545 nm, and the "blue" at 440 nm. The cones provide sharp colour vision in bright light, and most are found within a tiny region of the retina called the fovea.

While human vision is not sensitive to all the man-made and natural radiation illuminating the world, some animals can see well into the infrared and ultra-violet. But either way, "light" offers us a rich and exciting view of the universe.

First colourants and their making

Before humans wrote, we drew (see for example the cave painting on page 7). For millennia, across cultures and throughout the world early humans recorded their experiences and visions using images rendered with colorant materials found in their environment.

When mankind later took up the art of writing, it again turned to familiar materials: Then, as today, paints and inks were mixtures of colorant and vehicle which aids application of the colorant. For their paint, early artists and authors used charcoal and earth pigments such as rich red iron oxide and yellow ochre as colorants and mixed them with binders such as animal fat, tree sap or beeswax. As a liquid or paste these colorants could then be used to decorate objects of daily use such as clay pots or to colour objects in their environment such as cave walls. There are many very different theories about ancient images – from serving as mere decoration, not unlike our hanging paintings and photographs in our homes today, to having cultic meaning to capture the animals soul. But the pervasiveness with which ancient images are found throughout the world suggests that the drive to capture or record an image, an event, must spring from some facet of our

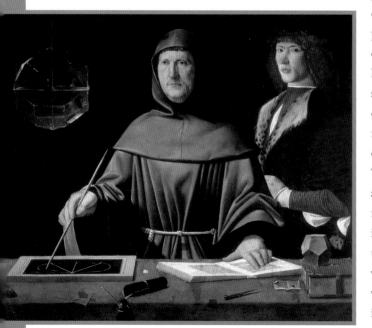

fundamental humanness.

Colorant materials for painting and fabric dyeing were highly valued and became important in trade and commerce. Bright, long lasting colors have always been hard to get and have been priced accordingly. Tyrian, or royal purple, first produced in the ancient city of Tyre was derived from mollusks and said in Roman times to be worth 10 to 20 times its weight in gold [1/2] Lapis lazuli has been mined in from the region in Kokcha Valley in Afghanistan for over 6000 years, and during the European Renaissance was used as the base colorant for Ultramarine Blue, often more costly than gold and so precious its use was reserved for the robes of the Christ child and Virgin Mary.

HP's colourants

Less then 200 years ago, after the Enlightenment and the advent of Chemical Science, colorants began to be manufactured synthetically. Today, the use of specially designed colorants makes possible the rich, vibrant colors found in Hewlett-Packard's Vivera Inkjet Inks. (Just as the ancient cave dweller and the Renaissance artist very likely wanted to express their experience or create major impact using the best available materials, so today do individuals seek out a printing system for their digital art and photographs that provides outstanding image quality and longevity).

And while a vivid and long-lasting colorant is essential for quality printing, getting that colorant onto the media – whether it be fine art paper, photo media or a cave wall – requires a vehicle to fluidize and bind

[1] Born, W., Purple in Classical Antiquity, *Ciba Rev.* 1937, 1, 111-118. The value of 10 to 20 times its weight in gold represents inflation over the value of the dye in Greek times, see Aeschylus', written in 457 BCE959 "The sea is there, and who shall drain its yield? It breeds precious as silver, ever of itself renewed, the purple ooze wherein our garments shall be dipped." *(959) Translation by Richmond Lattimore, The Complete Greek Tragedies, 1959, the University of Chicago Press.*

[2] Baker, J.T. 1974. Tyrian Purple: Ancient dye, a modern problem. *Endeavour 33:11-17*

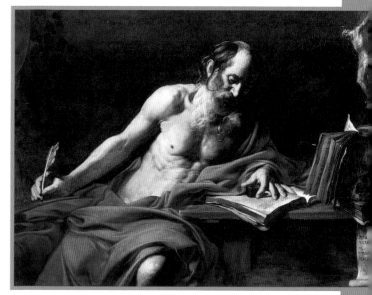

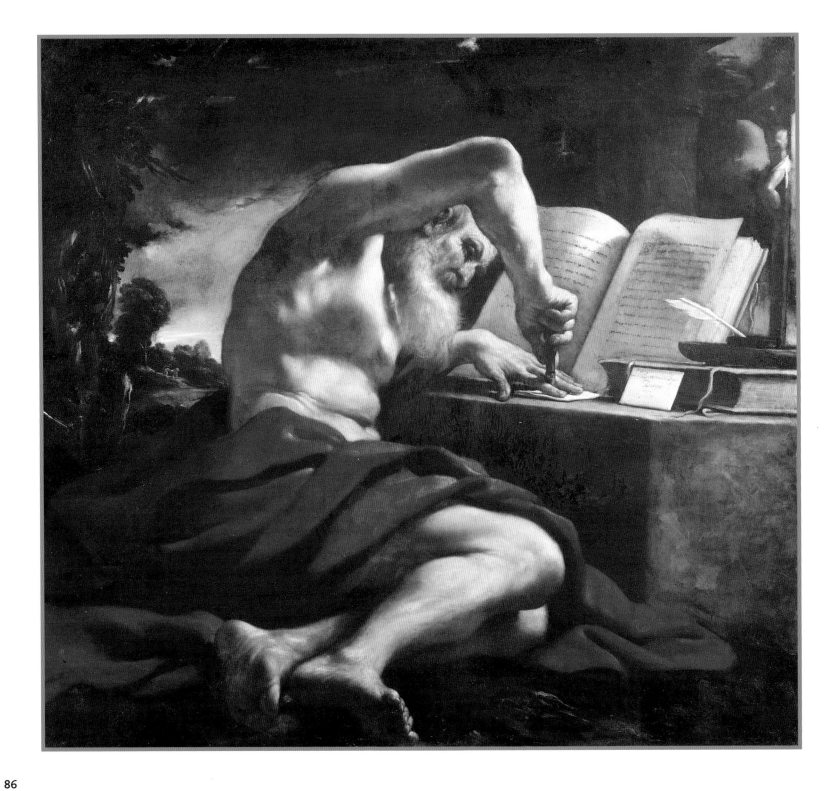

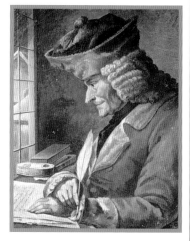

Unidentified Photographer
Voltaire in his Study, painting by French School, Musee Carnavalet, Paris
Bridgeman/Alinari Archives, Florence

the material to the substrate. Spit and pine sap may have performed adequately for ancient users, but for modern thermal inkjet the vehicle has many demanding functions and needs to be precisely engineered. Colorant and vehicle together make ink, and ink is a critical component of an inkjet printing system. The ink interacts with many different materials - from the ink cartridges and print heads, to the printer service station, and of course, the paper or media. HP Vivera Inks are carefully engineered to be chemically compatible with the diverse set of materials in the HP car-

tridge and to flow and eject effectively through the complex, highly tuned components inside the print cartridge. HP inks are developed jointly with HP photo papers for maximum compatibility and performance. The result is an optimal balance of key photo attributes - outstanding color, permanence and reliability

How are HP Photo Inks Formulated?

Ink formulation - an HP core competency focus for more than 20 years - is a complex, sophisticated science. Each ink must be approached with the specific customer requirements in mind, such as light fade resistant photos or vibrant, saturated business graphics on plain paper. HP ink formulations include carefully developed and often unique ingredients, each of which help ensure that desired print quality and print reliability are achieved. Among these are colorants, which provide the vivid color essential to HP inks and are a primary factor in fade resistance. The dyes used in HP inks are often proprietary and unique to HP, and have had years invested in their development and testing. The non-colorant portion or 'vehicle' of the ink starts with water - chosen as the base for its environmental and performance benefits. Humectants and co-solvents, are added to the aqueous base to dissolve the colorants and to prevent the nozzles in inkjet print car-

Unidentified Photographer
Scenes from the life of Buddha, painted stuff by Tibetan School, Musee Guimet, Paris
Bridgeman/Alinari Archives, Florence

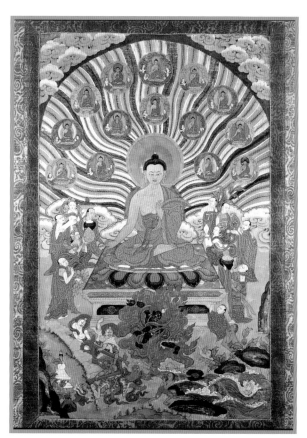

On left:
Alinari
Painting depicting Saint Jerome in the act of sealing a letter by Guercino, Private Collection, Rome, 1996
Alinari Archives, Florence

tridges from drying out. These solvents must be water soluble, non-reactive with the other ingredients and not decompose when heated to form the vapor bubble responsible for the "jet" part of inkjet. Surfactants are then chosen to control dry time and prevent printed areas from 'bleeding' into adjacent areas. Stabilizers, similar in function to food preservatives such as EDTA, are added to keep the ink in the cartridge fresh and ready for use. Each ingredient must be carefully selected to achieve the optimal balance - the critical differentiator for HP inks.

Ink Design

We continuously build on what we've learned. Ink programs often build on the program before: what did we learn? What worked well? What needs improvement?

The first part of a program starts with, "What are the customer requirements" – where will these inks be used? In a printer primarily for business documents? Or for photos? Each of the components must be selected with the end goal in mind: dyes for vibrancy and colour saturation on paper; dyes with the necessary light- or air-fade resistance. Also, the dyes need to be selected as a set – the yellow, cyan and magenta must be selected to balance each other so that the largest color gamut can be obtained.

Exhaustive testing

HP ink formulations undergo extensive testing and fine-tuning prior to introduction. Ink chemists typi-

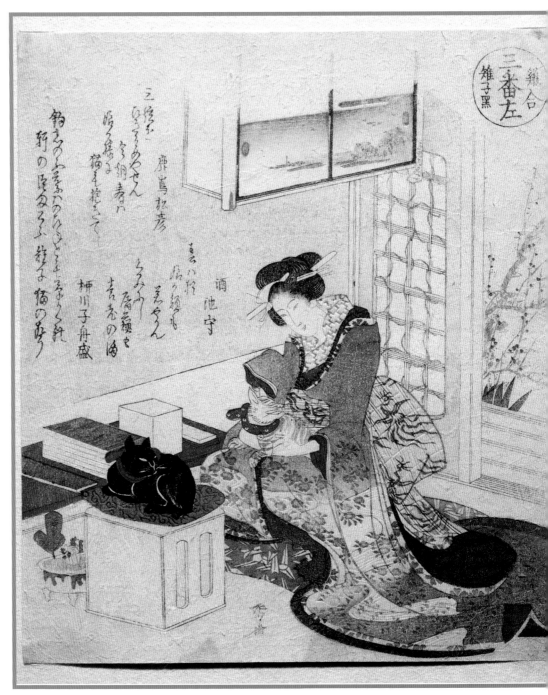

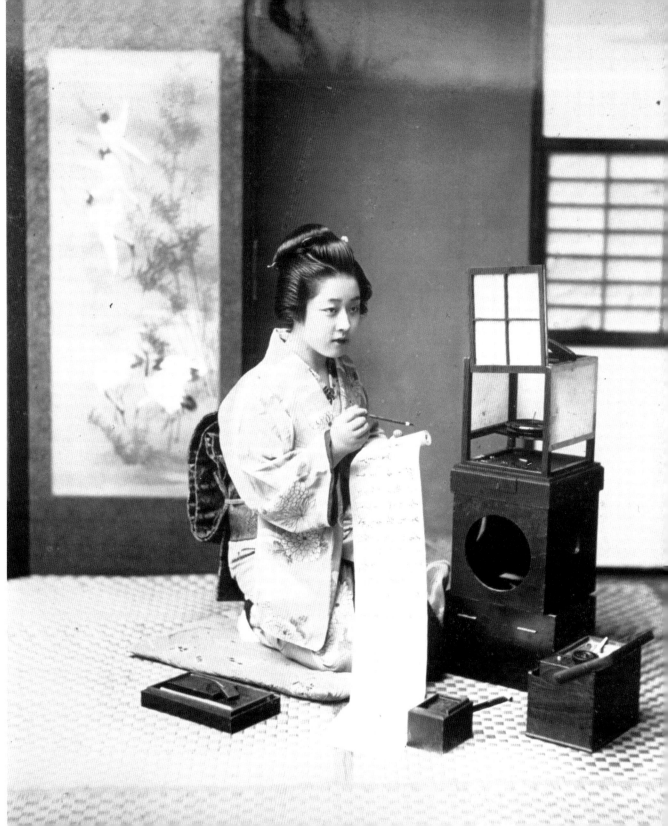

cally devote three to five years to designing up to 1,000 different prototype ink formulations. Prototype formulations that pass initial screening are then subjected to hundreds of additional tests see how the ink interacts with the inkjet cartridge, the printer— including the printer components that 'service' the cartridge for healthy operation - and the paper. More than 80 separate tests may be conducted on the print attributes of the ink and paper alone. A recent ink program consumed more than 22,000 liters of ink in the testing, optimization and development of a new ink formulation.

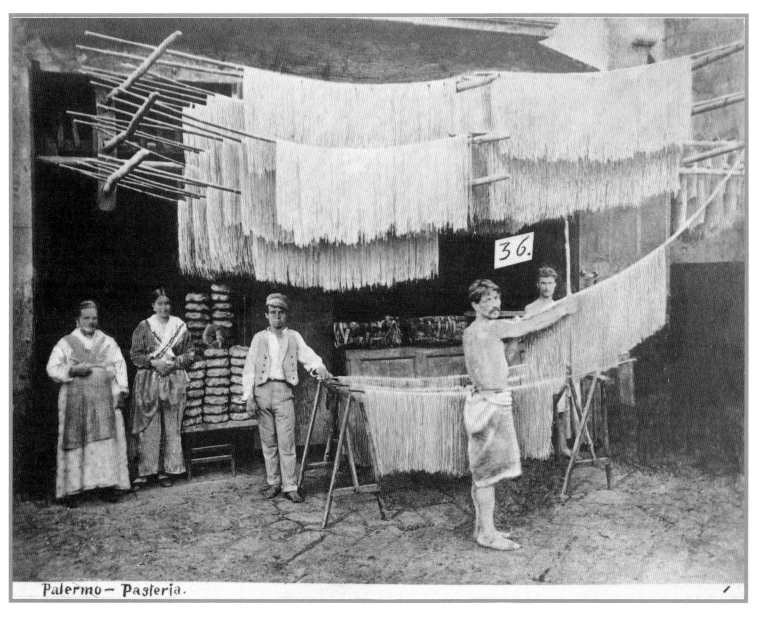

Palermo — Pasteria.

On left:
Unidentified Photographer
Writers with desks offer their
services to the illiterate, 1900 ca.
*Fratelli Alinari Museum of the History of
Photography, Florence*

Above:
Giorgio Sommer
Pasta making establishment,
Palermo, 1870 ca.
*Fratelli Alinari Museum of the History of
Photography, Florence*

Unidentified Photographer
Portrait of a woman in her
undergarments reading a letter,
1900 ca.
*Fratelli Alinari Museum of the History of
Photography, Florence*

Chère chère,
Je te prie d'agréer mes sincères et affectueux souhaits pour Noël et la nouvelle année

23.12.1903.

Eugenia

Je souhaite une bonne santé à toi et à toute ta famille. Reçoi mes faisers les plus affectueux

N.p.g
Photomontage for a greeting
card with small child,
December 23, 1903
*Fratelli Alinari Museum of the History of
Photography, Florence*

Giorgio Roster
Little girl at the chalkboard,
1910 ca.
*Fratelli Alinari Museum of the History of
Photography, Roster Archive, Bronzini
Capelloni donation, Florence*

On left:
Unidentified Photographer
"Spawn" by Louis Morris,
Private Collection
Bridgeman/Alinari Archives , Florence

Above:
Unidentified Photographer
Portrait of a young woman
signaling for silence. The
portrait is put on a postcard,
1930 ca.
*Fratelli Alinari Museum of the History of
Photography, Florence*

Elio Benvenuti
Two girls in the Ponte San
Giovanni grade school, Perugia,
1972
*Fratelli Alinari History Museum, Benvenuti
Archive, Benvenuti donation, Florence*

On right:
Colorpoint
Sherpa capital Namchee Bazar
in the Valley of Khumbu, in
Nepal: colored powders to dye
fabrics, 1995 ca.
RCS/Alinari Archives Management, Florence

Alinari
Mugs with paint covered brush-
es used for decorating ceram-
ics, Montelupo Fiorentino, 1992
Alinari Archives, Florence

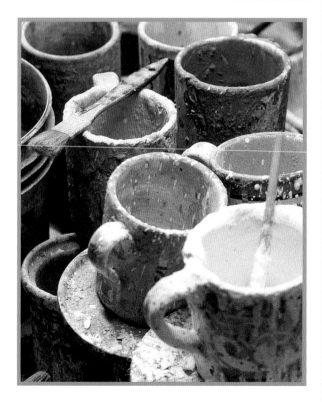

On left:
Colorpoint
Colored powders for dying
fabrics in Amber in Rajastan,
1995 ca.
RCS/Alinari Archives Management, Florence

Colorpoint
Nepal. Colored powders to dye
fabrics in Pashupatinah la
Benares, 1995 ca.
RCS/Alinari Archives Management, Florence

On left:
Topham Picturepoint
Red leaves
TopFoto / Alinari Archives, Florence

Hanya Chlala
Behind the Scenes, Scenery picture: Blue Paint, The Arena PAL
Picture Library
TopFoto / Alinari Archives

Biographies

Dr. Nils P. Miller

Ink/Media Senior Scientist Hewlett-Packard Company Business Unit – Inkjet Systems Organization

Nils Miller joined Hewlett-Packard in September of 1993 after obtaining his Ph.D. in Chemical Engineering from the University of Washington, Seattle WA USA, with a specialization in Physical Chemistry and Colloid & Surface Science. During the past 6 years he has been involved in the design and manufacturing of inkjet print media as an Engineer, Project Manager, and Supplier Manager, as well as leading various academic activities such as technically editing the Inkjet Media Fundamentals textbook (HP Internal). He now acts as the technical liaison between the Inkjet Ink and Inkjet Media R&D organizations.

Nils resides in the San Diego city center so as to be near art and music centers, and spends much of his leisure time in the remote areas of California either mountain biking, ski mountaineering, rock climbing, or hiking.

Dr. John D. Meyer

Director, HP Hardcopy Technologies Laborator Hewlett-Pakard Company

Dr. John Meyer is Director of the Hardcopy Technologies Laboratory (HTL) at HP Labs in Palo Alto. HTL's research areas include digital photography, colour science, scanning, advanced thermal inkjet technology, ink research, display technology and a range of user-orientated technologies to enhance and simplify the user's experience with imaging systems and processes. HTL also has several projects focused on new embodiments and applications such as photo-finishing for the Indigo liquid electro-photography printing technology.

As lab director, John's research interests embrace all elements of imaging systems, from image capture to the development of colour image processing algorithms and colour data standards to all aspects of output technology.

John became extensively involved in the application of colour reproduction technologies for offset lithography after receiving an undergraduate degree in physics from the University of Canterbury in New Zealand. While managing pre-press operations in England and the United States, he developed processes for colour separation, photographic duplication and a variety of supporting colour photography processes.

After joining HP Labs in 1979, he helped translate these processes into the colourimetrically-based colour reproduction practiced today on the office/home desktop. He was also part of the research team that invented and developed thermal inkjet technology.

Dr. Meyer holds a PhD in experimental low-temperature physics at the University of Southern California. He is a member of the board of directors of the Society for Imaging Science and Technology (IS&T) having completed a term as president in June 2001. He is also a member of the Faculty Advisory Board for the Center of Imaging Science, Rochester Institute of Technology. John is an inventor on one patent and a co-inventor on six others.

Dr. Ralf Leinemann
Communication Manager for HPs Imaging and Printing Group (IPG) EMEA

Dr. Ralf Leinemann has more than 15 years experience working in international PR, marketing and business development departments in the high-tech industry. He holds a PhD in Physics from the University of Tuebingen, Germany.

He joined Hewlett-Packard in 1989, initially in technical marketing for real time computer systems. Afterwards, Leinemann did product marketing for workstations and industrial systems. He then did business development for technical systems with a focus on the telecom industry, before he moved into public relations.

He started his carreer in PR as the PR manager for HPs computing systems in Europe, Middle East and Africa (EMEA). In that role he managed all external communication for that business in EMEA. He then integrated all communication for HPs business-to-business solutions. He is currently the communication Manager for HPs Imaging and Printing Group (IPG) EMEA with a focus on the consumer space.

Luanne Jane Rolly, Ph. D.
Senior Scientist Hewlett-Packard Company

Luanne has been a Senior Scientist in the IPG ink R&D organization since January 2001 and among her early accomplishments was leading the development efforts of the ink technology in HP's no. 58 photo inkjet print cartridge. This cartridge is the cornerstone of HP's 6-ink color printing systems, introduced in 2003, which set a new benchmark in photo-quality and lightfastness capability.

Luanne again played a key role in the development of the inks in HP's Gray Photo Print Cartridges (no. 59, no. 100 and no. 102), the foundation of the industry's first consumer 8- and 9-ink digital printing systems. . Luanne has several patents and patents pending for the inks in the nos. 58, 59, 95, 97, 99, 100, 101, and 102 ink cartridges, gray ink printing and other non-ink related materials and processes.

Prior to joining the ink R&D organization, Luanne spent 9 years in HP's Corvallis division in printhead development supporting electrochemical and physical deposition of metallic thin films for inkjet cartridge manufacturing. She also helped develop the theoretical model for heterogeneous bubble nucleation in Thermal Inkjet (TIJ) printheads, the process that makes HP's printheads work. For several years Luanne was the lead instructor for an internal class required of all new engineers titled, "Thermal Ink Jet Knowledge Module - FAB Print head Processes". More recently, she was a foundational contributor to HP's "Science of Printing" campaign, designed to illustrate and communicate the advanced technology that underpins HP's digital printing systems.

Luanne started with Hewlett-Packard Co. in 1983 as a summer intern at the San Diego Division where she was involved in the earliest ink and TIJ printhead development.

Luanne received her Ph.D. in Physical Chemistry in 1991 from the University of Oregon in Eugene, Oregon where she used photothermal deflection spectroscopy to study optical transitions and thermal diffusion in novel thin film materials and band-gap defect states in semiconductors.

Printed in Italy
May 2006